DARK CRIMES OF
JARROW

NATASHA WINDHAM

AMBERLEY

*This book is dedicated to the women who raised anarchy in Victorian Jarrow.
We raise a glass to you.*

First published 2021

Amberley Publishing
The Hill, Stroud
Gloucestershire, GL5 4EP

www.amberley-books.com

British Library Cataloguing in Publication Data.
A catalogue record for this book is available from the British Library.

ISBN 978 1 3981 0975 9 (paperback)
ISBN 978 1 3981 0976 6 (ebook)

Typesetting by SJmagic DESIGN SERVICES, India.
Printed in Great Britain.

CONTENTS

ACKNOWLEDGEMENTS

I'm incredibly thankful to Kevin Blair, who gave me unlimited access to his collection of Tyneside photos. Thank you to my father, Ewen Windham, who photographed Jarrow streets in the rain after I continually nagged him. I also appreciate the help of Stewart Hill, who shared his military research of the Bentham brothers on the night England beat Denmark in the Euros. Thanks to Margaret Davies for granting me permission to use her photo of the Jarrow Caledonians. Further appreciation and thanks are given to the Padden family, who shared their ancestor's photograph with me and were happy to answer my questions. Thank you to Suzanne Pagès-Slassor for the photo of Jane Merrells – your skills were invaluable and hopefully, you are now in frequent contact with your distant cousins. Further thanks to Malcolm Smith, who shared several photos of Victorian Durham Constabulary helmets, etc., with me from his own collection. And lastly, thank you to Nick Grant for his patience and unwavering support.

INTRODUCTION

Welcome to Victorian Jarrow. It was a town of shipbuilders, pub crawlers, churchgoers, newcomers, bar brawlers, shopkeepers, and sex workers with weapons of fire pokers, police batons, guns, knives, feet, teeth, fists, stones, rocks, and boiling water. It was the town of female-focused brawls with a Geordie drawl and sporadic bar fights where sudden brutality and murder had begun with the Viking invasion of 794 and continued through the centuries in the tumultuous town beside the River Tyne where crime statistics swelled. It was the town where Ann Brown of Albion Street, in 1881, had caused such a commotion after she attacked her husband, their daughter ran into the street and screamed 'Murder! Murder!' It was the town where PC Maughan and PC Adams raced to the scene and attempted to separate the fighting parties, when an enraged Ann swung a fire poker at the policemen and struck them both. It was the town where Police Superintendent Harrison withdrew the assault charge against Ann because he did

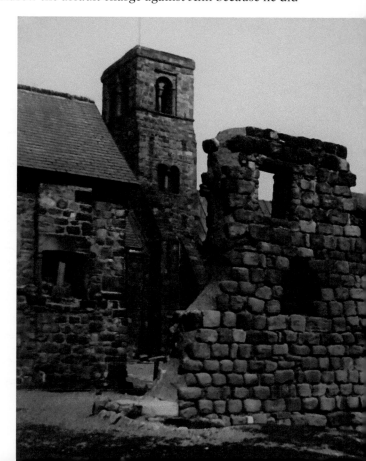

St Paul's Church, Jarrow, from a glass slide. (Source: Natasha Windham)

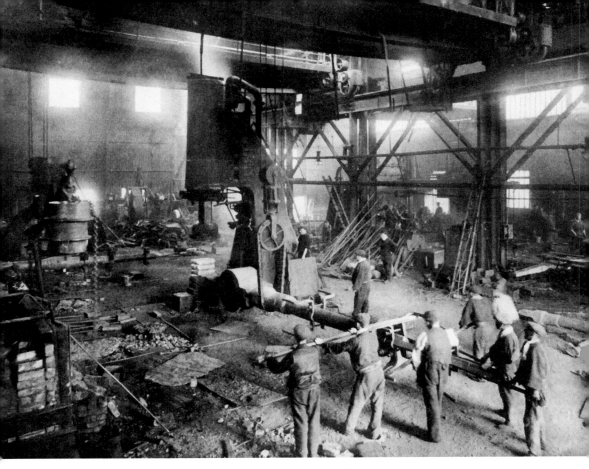

The forge at Palmers Shipyard, 1910. (Source: Kevin Blair)

not deem it serious enough to warrant a fine. It was also the town where the *Jarrow Express* labelled Ann Brown a domineering, violent fishwife, or, as they eloquently wrote, 'a virago'.

It was the town where a drunken Michael McGintry, in 1883, had savagely assaulted PC Ballan on Stanley Street and howled when arrested, 'You're more like dogs than Christians!' It was the town where Thomas Coyne, in 1883, respectably dressed and recklessly drunk, knocked a man's head through a window in Pitt Street after a heated exchange sparked by his demand to know where his victim worked. It was the town where Jane McColl, in 1887, plead guilty to using obscene language in the street after blaming her children for annoying her. It was also the town where Mary Ann Hughes and Mary Graham, in 1878, had started a war on the streets of Jarrow Church after Hughes had insulted Graham's husband when passing by the door. It was the town where Graham followed her, the battle commenced, and Hughes blackened her opponent's eyes, hurled stones at the injured woman, then dragged her by the hair along the cobbled street. It was the town where their conflict abruptly ended after Hughes had thrown a bucket of water into Graham's house, and it was the town where Graham had held her torn clumps of hair aloft in the local police court as

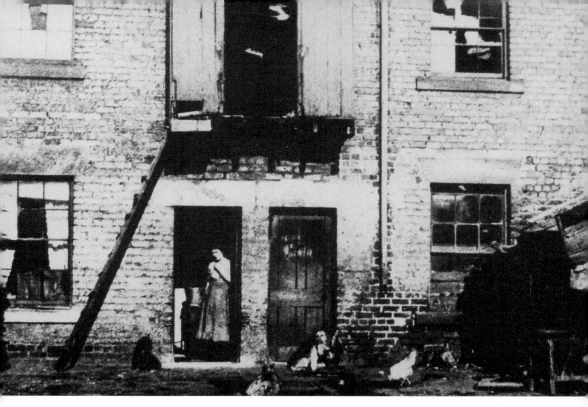

Above: The 1920s backyard of a house on Albion Street, Jarrow. (Photo courtesy of Kevin Blair)

Below: The scene of many drunken nights in Jarrow: Staith House, Peason Place. Date unknown. (Source: Kevin Blair)

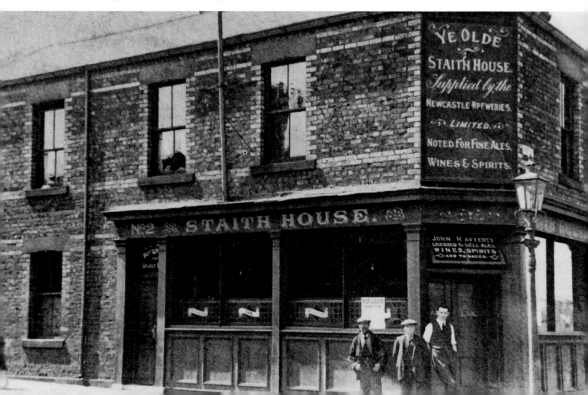

evidence, before learning they would both receive a fine for their 'hauley-pulley' conduct in the so-called quiet streets of Jarrow on Tyne.

It was the town where heavy industry flowed and policemen were forever busy, hauling the great and good of Jarrow's thriving pub trade to the local cells to sleep until sober. It was the town where a commentator for the *Jarrow Express* buried his identity and wrote under a pseudonym while commenting on the comings and goings of topical gossip and newsworthy items like complaints of drunkenness or crime, the weather, rats, and a Jarrovian visiting Tynemouth. It was the town where occasionally he wrote about all five topics in one sitting, one article and one short lament:

Sunday was a glorious day. Blue sky, brilliant sunshine, and a mild breeze. Though surprised at the sudden change, the good folks of Tyneside did not neglect to take advantage of the magnificent weather, and all who could, sought pleasure and enjoyed themselves at the usual resorts. All, did I say? Well, hardly all. Among the crowd were several stray specimens of the genus rough from Jarrow, Willington, Howdon and Wallsend, and they were entertained by the executive of the municipal authority of Tynemouth. One of the roughs, hailing

Drone shot of Jarrow by Ian Turnball, summer 2020.

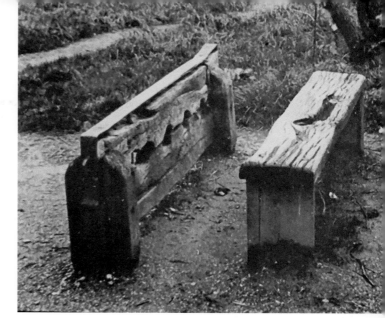

An image from a glass slide of the stocks that once stood at St Paul's Church. According to Jarrow Hall, the stocks were last used in 1877 to punish a young boy, George Proud, for skylarking, horseplay, or pranks.

from Jarrow, I am sorry to say, distinguished himself by spitting across a lady's face, for which the luxury he was only charged 2s 6d and costs. While speaking of roughs I may just mention a scene I witnessed the other day. Two or three young fellows, who from their appearance ought to have had more sense, had become possessed of some rats, and following the example of the pigeon-shooting, greyhound-coursing aristocracy, they determined to have some 'sport'. They accordingly carried the rats in a tin can to the vacant ground in front of Prince Consort Road, where the little animals were released one by one, and stoned to death to the accompaniment of volleys of oaths. This lasted for about half-an-hour. An invitation to meet the mayor and other gentlemen at the stone house in High Street, written on blue paper, and delivered by a man in a blue coat to each of the vivisectionists might prevent a recurrence of the scene. ('Leproghan', *Jarrow Express*, 13 May 1881)

It was the town where bastardy orders were printed in newspapers and sex workers were shamed, jeered, and dragged to stand trial by semi-professional judges built of doctors, councillors and chemists. It was the town where the homeless were chased from their chilled, damp and street-worn beds and ordered to leave Jarrow forever, and it was the town where Margaret Lynch and Catherine Elliot, at Old Church, in 1880, armed themselves with obscene language and fought over a dozen ducks. It was the town where Lynch assaulted Elliot after their poultry huddled together during feeding time. It was the town where Lynch held Elliot by the throat and struck her with a spade, earning herself a dismissal from court after the local magistrates determined the assault to be too trivial. It was the town where George McConachie, in 1888, was remanded after stealing a piece of scented soap from a store. It was the town where the complainant, Mrs McDonald, refused to press the case against George because he did not have a mother. It was the town where William Proudlock, aged thirteen,

A CHALLENGE TO THE TOWN.

William Cunningham, a young man, was charged with having been drunk and disorderly in Ormonde-street, on Saturday. He was also charged with assaulting the police officers in the execution of their duty. P.C. Moralee stated the facts of the case. Defendant got drunk and challenged the whole town to fight, and on the police officers requesting him to go home he became very violent, kicking the officers. Fined 2s 6d for being drunk, and 5s for the assault, or 14 day's imprisonment.

A DEAR BOTTLE OF POP.

John Connolly, a young man, was charged with having been drunk and disorderly on Saturday; also with assaulting Elizabeth Lambert, at the same time. Defendant had gone into a small shop in Cambrian-street and asked for ginger beer, for which he refused to pay, striking the woman when she asked for the money. Fined 7s 6d and costs.

A LANDLADY THROWS A BRICK AT THE LODGER.

Martin Lyons was charged with having been drunk and disorderly in Stead-street, on Saturday; also with assaulting his landlady at the same time. The woman and her lodger had quarrelled, the former struck the latter with a brick, and when P.C. McLeod came upon the scene, defendant was dragging the woman about by the hair of the head. Fined 5s and costs, and bound over to keep the peace. The woman was also bound over to keep the peace for six months.

An assortment of Jarrow Police Court cases, 13 May 1881, *Jarrow Express*.

in 1887, earned himself a 1s fine after throwing snowballs at startled women along Ormonde Street as they used their umbrellas as shields.

It was also the town where the rainclouds gathered as the Edwardian era drifted into view with delinquency and further depravity. It was the town where overbearing William Dial, thirty-two and consciously abusive, walked from a manslaughter charge after viciously attacking his twenty-three-year-old wife Louisa after she returned home late. It was the town where the tradition of children gathering at the railway station in winter and snowballing every passenger stepping off a train continued. It was the town where James Burke, in 1902, lifted a weighty paving stone and assaulted Thomas Riley near the Ferry Landing, earning a 10s fine after a grudge got the better of him. It was the town where, in 1902, Mary Ann Bentham was charged with assaulting Mary E. Mulcairns, while Mary E. Mulcairns was charged with striking Ellen Nee, while Ellen Nee was charged with attacking Mary E. Mulcairns. It was the town where the police court proceedings descended into chaos when all three women's rowdy voices collided at the same time after the local magistrates learned the previous two-day argument had only ceased after the women had dumped water over each other, before rising again on day two and abruptly ending a ferocious quarrel when Ellen Nee had swung a kettle and struck a Mrs Mulcaster with such force, the kettle would be forever dented on one side. It was also the

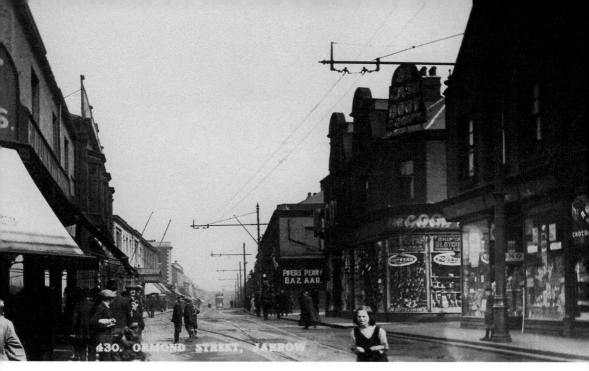

A postcard of Ormonde Street, Jarrow. Date unknown. (Used kindly with permission of Kevin Blair)

town where the confused magistrates were unable to hear a word of evidence from the squabbling women and, exasperated by the show of threatening tones and deafening voices, they called the proceedings to a premature halt and bound the women over for six months at the cost of £10 each and informed them they would be paying for the costs of the tempestuous court case too.

Grounds of St Paul's, Jarrow, close to where the streets known as Jarrow Church were, autumn 2019. (Source: Natasha Windham)

Victorian Jarrow welcomes you, while Edwardian Jarrow warns you nothing has changed. They are the rough town with the jagged edges, characters with bellies full of beer, warring women, belligerent brawlers, and families collapsing into pockets of poverty while their neighbours sparred with police constables in the gas-lit streets. It was the town where the uniformed men of the Durham Constabulary with their helmets and capes ducked stones and swung truncheons in their own defence. It was a town greater than Wallsend, a smidgeon better than Hebburn, brighter than South Shields, and often bristling with criminality. This book opens with murder and closes with death. Welcome to the Jarrow of the past.

ALLEGED OBTAINING OF MONEY BY FALSE PRETENCES.

A LABOUR UNION CASE.

At Jarrow Police Court, yesterday, John Brown labourer, was charged with obtaining 6s 8d by means of false pretences, from the National Amalgamated Union of Labour. Mr Jacks, South Shields, prosecuted, and said that the members of the Union who were out of work through the Engineer's strike got 6s 8d per week. Accused applied on the grounds that he was out of work through the strike, and presented a certificate to that effect and received 6s 8d. It afterwards transpired that he had been working at Hebburn Hall Quarries, and it was held that in consequence he had no right to benefit. He got other money besides for the same benefit. The note certifying that accused was out of employment through the strike was signed with the name of Mr Hunter who denied that it was in his handwriting.

Accused was remitted to the Sessions, bail being allowed.

A DISCLAIMER,

[To the Editor of the *Jarrow Express*.]

DEAR SIR,—Would you be so kind as to print the following in your valuable paper :—

N. A. U. L.

That I, John Brown, 134. Queen's-road back, Jarrow, Secretary of the late Lock-out Committee, am not the J. Brown who was charged at the Jarrow Police Court, on March 2nd, 1898, for obtaining money by false pretences and was committed to the Quarter Sessions. By putting this in your paper you will oblige,—Yours truly,

JOHN BROWN,

134, Queen-road back, Jarrow.

The perils of sharing a common name, *Jarrow Express*, 4 March 1898.

CHAPTER 1

OH, DOCTOR SAUNDERS, I DIDN'T DESERVE THIS

This is the story of two murders, two countries, two lives brutally taken, one acquittal, and one chilling walk to the gallows. 3,540 miles from Jarrow is Washington DC, the capital city of America and home to the sitting President of the United States. In early February 1859, the Honourable Daniel E. Sickles, a serial philanderer and elected Democratic senator to Congress, received an anonymous letter. The handwritten words described his young wife's twelve-month affair with Philip Barton Key. Key, attorney for the District of Columbia, and son of the author of the *Star-Spangled Banner*, was a charming, jovial, and well-liked member of high society. The letter detailed the clandestine meetings, the house where the lovers would meet and, most intriguingly, how the two secretly signalled to each other without Daniel Sickles' knowledge.

After investigating the contents of the letter, Sickles confronted his wife, Teresa. She admitted to the affair and penned her confession in front of her husband and two witnesses. Night faded to daybreak, and Sickles stood at the window waiting for Key. His eyes narrowed with bitterness when Key walked by and waved a handkerchief towards the house. Sickles called out to his friend, Butterworth, to go after Key and stall him. As Butterworth rushed outside, Sickles went upstairs and picked two guns from his collection. He walked coolly to Pennsylvania Avenue, opposite the White House, where Butterworth and Key discussed trivial matters.

'Key, you scoundrel; you have dishonoured my house. You must die!' Sickles said sharply, raising both guns in Key's direction.

'What for? What for? Don't! Don't shoot me!' a thoroughly panicked Key cried, reaching inside his breast pocket. The defenceless man threw his opera glasses at Sickles in a desperate bid to protect himself.

The first shot of the revolver was directed at Key's groin. He stumbled backwards, fell against a tree, and pleaded for his life.

'You villain; you have dishonoured my house, you must die,' Sickles said, shooting him two more times.

Minutes later, the widower and father of four, Key, breathed his last breath. Sickles was taken into police custody on the charge of first-degree murder. His friends visited him in his prison cell. Pale and clammy, he answered all questions asked of him. 'I could not live on the same globe with a man who has dishonoured me,' he explained to his friends, still armed with one of his trusted guns.

Sickles stood trial for the murder of Key. He accused his victim of destroying the honour of his wife, and although Mrs Sickles' handwritten confession was inadmissible in court, the press released it on the front page of newspapers. Sickles claimed the killing had been a crime of passion. In fact, his case was the first time that temporary insanity was used as a defence in US history. As the trial ended, he was found not guilty, and the judge ordered his immediate release. His lawyer cheered, a Captain Wiley kissed his cheek, every juror shook his hand, and he returned to his broken marriage and his tattered reputation.

Five months later, the notorious and widely reported public slaying of Philip Key had captured the hearts and minds of tabloid readers worldwide. One such reader, John Shafto Wilthew, a fifty-five-year-old gatekeeper at Palmers Shipyard, had lived in Jarrow for two years with his wife Susannah and their family. When drunk, violence would suffocate their relationship, and he would cruelly beat Susannah. They lived a poor existence in a two-bedroom dwelling close to the railway station, and on Tuesday 19 July 1859, the drudgery of everyday life in the Wilthew household would be viciously destroyed by John's own murderous hands. But first, he would put ink to paper and share his own thoughts.

My first jealousy was Saturday afternoon. I keep house in Drewett Place, Jarrow, second storey. Below us lives an Irishman, who takes in lodgers, one of which plays a tin whistle. With him to my great surprise I found familiarities pass between them which made me think all was not right! As I could see and observe from my terrace window which overlooks the yard and was fully confirmed of the fact, Sunday morning I charged her with it. Left the house all day and returned home at ten o'clock quite steady, not tasted drink. After ten o'clock, near eleven I went out of the house to do a job. Coming from the steps, I found ginger pop bottles outside of the window. I saw what they were doing there. Saw one of Mrs Sickles' signs. My daughter said it was a broken one. I felt it and found it was whole and threw it in the privy. Monday night saw on top of the stairs two bricks to keep ginger pop bottles on the stand, on which she has them, before filled. There was one at each post, in which position they were during the early part of the night until dusk. She found that I was going to sit up until she went to bed. I went to look at the bricks again to see if they were in the same position. I found them two put together facing their house. I then was thinking this was the sign that no business could be done. I set them upright one at one end and the other at the other, opposite each other. This was dark. My daughter was rather late coming home. She stood talking with others at the foot of the steps. My misses went down to speak to her. She found the bricks in the yard. Not right for her signal. She put one to the other to make two. These she brought upstairs as there were only two. The other was shielded from the house by being in front of the post.

Jealous of the man with the alleged roving eyes and tin whistle, John plotted his wife's murder. By Monday night he would retire to bed knowing Susannah would

not live to see the sun rise on Tuesday morning. Her brother George Charlton would be the first to witness his dying sister's silent plea for help, followed by neighbour Mrs Jane Hart.

> I am employed as a labourer in Messers Palmers Shipbuilding Yard. I lodged with my sister, who is fifty-one years of age. A few minutes after four o'clock on Tuesday morning I saw Susannah come into my room in a dreadful state and being unable to speak, she beckoned to me. She was holding her chemise to her throat. The blood was running down the inside of her nightdress and down her legs onto the floor. I immediately jumped out of bed and gave an alarm. I called to the children, saying, 'Good God, your father has cut your mother's throat!' Whilst I was standing in the kitchen, John Wilthew came through, and went down the backstairs leading to the privy. In two or three minutes he returned and walked quietly to his bedroom. As he was going past, I said to him, 'What is this you have done?' He made a reply of some kind, but I could not tell what it was. I told the daughter Elizabeth to go for the doctor, which she did. The screaming of the children brought several neighbours to the spot.
>
> I am the wife of William Hart, a caulker, and live next to Wilthew. On Tuesday morning, I was awoke and out of my rest by the cries of 'murder!' I immediately jumped out of bed and on looking out the window I saw Elizabeth Wilthew running out of their back door in a very excited state. I ran downstairs and went into the Wilthew house, when I saw John Wilthew standing trembling in his own room, with his arms widely extended. I did not notice any blood about him. He had a waistcoat and trousers on. I next saw Mrs Wilthew coming out of the privy and bleeding very much from the throat. On seeing this, I became greatly alarmed and went for Mrs McKay. I then went into a fainting fit.

Jarrow surgeon Charles Saunders soon arrived and tried in vain to save Susannah's life. He cleaned the 5-inch wound and sewed it shut while she drifted in and out of consciousness. In a cold and pulseless state, she whispered to him with a fearful look in her eyes, 'Oh, Doctor Saunders, I didn't deserve this.' They were the last words Susannah Wilthew would share with the world. Moments later, by the warmth of the fire, she died in the doctor's arms. George Charlton confirmed Susannah's fate.

> My sister died soon after the doctor arrived. She lost a great deal of blood both in the kitchen and the bedroom. When I went into Wilthew's bedroom I found him lying in a pool of blood on the floor, with his throat cut. I do not know whether he did it in the privy. I took a razor from below the bed. On going into the privy shortly afterwards I found some blood on the seat and floor. The razor I found belonged to me. I laid the razor on the chimney piece. I think that John Wilthew cut my sister's throat. She had told me that her husband has occasionally threatened to take her life. He is of ill-tempered

disposition and of intemperate habits. A few weeks ago, on returning home drunk, a few words arose between them, when he seized hold of a razor, but before he could inflict any injury it was pulled out of his hand by one of his sons, who has since enlisted as a soldier. I know no reason why Wilthew has committed the deed. He was a very violent man, and sometimes when he returned home drunk, he used to ill-use his wife and break the furniture. On going to bed Monday night, at eleven o'clock, I left them both sitting up in the kitchen. They were not quarrelling. Two sons and a daughter sleep in the same room as them.

While Police Sergeant Salter and PC Davidson took possession of the murder weapon, Dr Saunders dressed John Wilthew's wounds. By the afternoon, he was sitting peacefully in bed. Jane Hart and Jane McKay visited the Wilthew home and spoke to John. He answered their questions calmly, stating, 'I made up my mind to do the job as four o'clock struck. I did it while she was sleeping.'

An astonished McKay said, 'What had put into your head to do such a thing?'

He looked up from the bible he was reading. 'I do not think I have done anything but what I ought to have done.' He then told Sergeant Salter, 'My wife has been an idle woman. It was upon my mind that I was going to do this rash act, as she clasped her hands last night as I was writing. I was quite cool when I did it.' As Salter took into possession Susannah's chemise and Wilthew's shirt and flannel, he continued to talk. 'I feel quite justified in the way I killed her. I feel quite justified in the act. I know the punishment that awaits me before another tribunal and am quite ready to meet it.'

While the inhabitants of Jarrow gossiped about the shocking murder, the local inquest into Susannah's death passed without incident, though her husband's request for a second glass of glass of gin in the waiting room was declined after Dr Saunders told Sergeant Salter one was more than enough.

Elizabeth, the crying daughter of John and Susannah, had shared murky details of her parents' marriage. 'Two years ago, he struck my mother with a poker,' she admitted, then spoke of the morning her mother was murdered. 'When I got up, I said to my father, "You villain, what have you been doing?",' she had admitted. And when she left the stand in tears, she shot a glance at her father and hissed, 'You are a bad man.'

Seven days after Susannah Wilthew's death her husband stood trial at the Durham Assizes for her murder. Witnesses such as Sergeant Salter, Dr Saunders, the Wilthew's neighbours, Susannah's brother, her son William, and several policemen gave their evidence with steady voices and honest words. Elizabeth, the Wilthews' daughter, fainted in the witness box during the judge's lengthy questioning, and had to be carried out of court. Salters' statement was particularly damning: 'While conveying the prisoner in a cab from South Shields to Jarrow, he put his face into mine and said, "When I did the deed I intended to die".'

The jury retired for thirty minutes and delivered a guilty verdict. The judge sternly questioned Wilthew whether he knew of any reason why the sentence should not be passed.

'Nothing,' the condemned man murmured, gazing gloomily at the floor.

Judge Watson sat the infamous black cap upon his head. 'John Shafto Wilthew, you have been convicted of the crime of murder, and that of your own wife, the mother of eleven children; and for many years your partner, she whose fidelity you had disputed. You are a person perfectly sane, and perfectly conscious of your own acts, and you have indeed committed a great crime. The law has attached the punishment of death to that offence. The law, however, at the same time gives you that which you did not give to your partner, it gives you time to consider, reflect and repent. You have only a short time to live. In that short time, I admonish you to obtain the advice of some of the ministers of religion, and to apply yourself to repentance, I trust that you will actively consider the matter, apply your mind to the comforts of religion and prepare to meet your maker. It only remains for me now to pass upon you the awful sentence of the law, that you be taken from the place whence you came, and from thence to the place of execution, and that you be hanged by the neck until you are dead, and that your body be buried within the precincts of the prison in which you have been confined. May God have mercy upon your soul.'

Wilthew's day of death was set for Thursday 11 August 1859. Alarmed by the swift wheels of justice, Dr Robinson of Newcastle upon Tyne launched a petition to save the condemned man's life. Robinson believed Wilthew suffered from an unsound mind and the speedy manner of the trial had not given Wilthew's friends ample time to mount a defence. The Secretary of State dismissed the calls for leniency and declared no reprieve would be granted.

Visiting friends and brothers-in-law attempted to persuade Wilthew his mind was unwell. They implored him to believe the ginger pop bottles were not Sickles' signs, but he brushed their frantic worries aside. The night before his public execution, he ate supper, smoked his pipe, and went to bed at 10 p.m. At 5 a.m., he was awoken by the guards. He washed, dressed in a black suit, surtout coat, trousers and a waistcoat, before he was visited by a chaplain. After prayer, Wilthew ate breakfast. At 7:40 a.m., Under Sheriff Wooler, the governor of Durham Gaol, four sheriff officers, Lieutenant Reeves, the deputy governor, the surgeon, and two gaol officials arrived to walk Wilthew to the scaffold. As they marched, the chaplain read the 51st Psalm. When they reached the grand jury room, Wilthew was introduced to the executioner, George Askren. The prison bell sounded at 7:50 a.m. and Wilthew's arms were strapped to his side. A crowd of 5,000 curious faces awaited his appearance on the scaffold while the houses closest to the solemn scene had their blinds drawn.

With a confident gait, Wilthew and the chaplain climbed the scaffold outside Durham Gaol. The former Palmers gatekeeper quietly gazed at the sea of expectant faces in the crowd as a noose was placed around his neck. The hangman then

A LETTER BY WILTHEW.

The following letter was written by John Shafto Wilthew a few days before his execution:—

Durham County Prison, 5th August, 1859.

My dear Son and Daughter,—My dear Isabella,—You will ere this time had an interview with my unfortunate, I may say, orphans. Permit me ere I close this short life I have to live to entreat that you will be kind enough to use your care over them; and to let me advise their attendance at Sunday school and church, combining therewith their education, either by day or night as it may suit, and if possible to make them trades, an offer which none of the others ever had a chance. As it is, good may come out of evil, for who can fathom the depths and lengths of that incomprehensible Being who subdues all and everything to Himself for His all-wise ends and purposes? And when they arrive at proper age to be able to recognise their true and righteous debtors, I trust that they will redeem their debts—pay them off with good and lawful money, with interest; and ever bearing in mind to the end of life's journey their deep sense of the gratitude which they owe their benefactors, and with due and dilligent submission, industry, and other good, honest, and attentive conduct, they will behave themselves to those (and all) under whose care they may be put. And let me enjoin on them to lead a good, moral and religious life, which only can secure the esteem of that great and visible Being, our Lord and Saviour, who will punish or reward us according to our merits, whether they be good or evil, and which religious and pious life will only constitute a permanent happiness here and hereafter, and which will materially assist in washing a stain which I have in an evil hour casted and blotted the family name. I am quite aware that they will need like others of their age, correction and chastising. I hope it will be inflicted in love and charity, considering mild punishment (words if possible) answers the wiser and better end. And do let me intreat that my name and act will not be thrown up to them to mar or wound their feelings, but let my body, or the remembrance thereof, sleep in quiet and in peace, desiring only your earnest prayer to the Almighty God to have mercy on my poor soul.

John Wilthew wrote a letter to two of his children and it was later printed in the *North and South Shields Gazette*, 18 August 1859 (part 1).

pulled a white cap across Wilthew's face, obscuring views of Durham basking in sunshine. Under the intense silence of the waiting crowd, the hangman tied Wilthew's feet together then shook hands with him. The clock struck 8 a.m. and the condemned man respectfully bowed his head. Within moments, he plunged through the trapdoor to his death. To add further horror to an already sickening sight, the self-inflicted wound on his neck tore open and the white cap turned red. At 9 a.m. the body was cut down and hastily buried behind the walls of the prison. The clothes Wilthew had worn were confiscated under the sheriff's orders and the rope was also burnt to stop them becoming trophies for the hangman.

There were two villains in this story: Daniel Sickles and John Wilthew. While Sickles would continue to lead a prominent life in the public eye, fighting in the War of Independence and losing both his legs to cannon fire, Wilthew would pay the ultimate price for his crime. This slightly dubious link connecting Sickles to Wilthew were the widely gossiped wave of a handkerchief that morphed into two bricks with ginger pop bottles on the steps of a tenement building in Jarrow.

Now, my dear Isabella, as my time is near due to satisfy the laws of man for the act which in an evil hour I committed, claiming as a compensation the resignation of my corporal or bodily existence, and surrendering my soul to the Almighty God who gave it, and whose I trust I shall be, through our Great Redeemer our blessed Lord Saviour, who I hope, through my earnest and hope true and faithful repentance, will in his Divine Majesty intercede and plead for the remission of my manifold sins to our great Almighty God, in whom and through the interest of our blessed Lord, Saviour, and Redeemer of Mankind, obtain mercy and forgiveness. Still, my dear Isabella, I hold it a duty I owe you and myself to add and give my last advice, which is—let me council you and your dear husband to live a godly and sober life, and do attend church every Sunday, and as often in the week days as possible. Do lead a good, moral, religious, and virtuous life, by which you gain all and lose nothing: besides religion arms you with a weapon which will, by properly thinking of it, defend you against all attacks of your enemy the devil. It will enable you to lead a most happy life: indeed it constitutes heaven on earth and an everlasting glory hereafter. If I had had half, and I may say the ¼ part, of the religion which I have received under the very Reverend the Chaplain, Mr Greenwell, I sincerely believe the sad calamity would not have befallen me, and for which I am heartfelt sorrowful, and hope forgiveness.

Mr Greenwell's spiritual instructions over my salvation has been incessant and careful, using every interest, influence, and supplications with Almighty God on my behalf, for which I am heartfelt and deeply obliged to him, for his religious powers and talent exercised in endeavouring to obtain with the Almighty the remission of my sins, which I hope he has, with my true and faithful repentance in Christ Jesus, through his merits and blood, obtained with the Father of all Mercies, in His *kingdom of everlasting glory.*

The kind respect which all the officers of this prison have shown towards me in my unfortunate position is beyond all praise, which entitle them to sincere thanks and well wishes.

Give my best respects to all my family; also Mr Willmot and family when you see them, not to forget my dear sister Elizabeth; also aunt Mary and family. And that I beg to add I sincerely forgive the world freely, and I hope they forgive me.

Accept this, my last farewell. Keep yourself constant and true to your husband and rich in love, then farewell, and for ever.—Your loving father,

JNO. S. WILTHEW.

Part 2 of the letter.

As he read the scandalous newspaper reports portraying the Sickles' unsteady marriage, his mind conjured ways his wife had been frequenting with other men. With his thoughts poisoned with murder and madness, he signed his own warrant of death. The *North and South Shields Gazette* would remark, 'It was rarely indeed, in our country, that retribution follows so close upon the crime. Being no mad-doctors to override judge and jury.'

Mrs Jane Hart's words from Susannah's Jarrow inquest described frequent violence. 'I saw Mrs Wilthew five minutes before she died. She was sitting in the kitchen where Charlton slept. The only words I heard Mrs Wilthew utter were, "Sweet Jesus look down upon me." They often quarrelled. I have several times heard Wilthew, both when sober and drunk, threaten to take his wife's life. I once saw him throw her down on the floor, rifle through her pockets of all the money she had, and then kick her. Mrs Wilthew was not a strong woman. Wilthew was a very wild man when he was drunk. When the deceased was abused or ill-treated, she never retorted.' Domestic abuse remained rife in Victorian Britain and sadly Susannah was one of Jarrow's many victims.

CHAPTER 2

I TAKE YOU TO BE WITNESS THAT
JOHN CONLIN HAS STABBED ME

An eventful year for Jarrow, 1863 ended with national newspaper headlines heralding yet another local murder, but what had become of the previous months. With normality setting the scene in March, the workmen of the Lake Chemical Works of East Jarrow, along with their wives, were treated to tea, a firework display, and a bonfire in celebration of the marriage between the Prince of Wales and Princess Alexandra. In shipbuilding news, *Georgia*, an enormous iron ship considered a 'magnificent vessel' by the *Newcastle Journal*, launched from Palmers, and destined to support the slavery-laden cotton trade between Liverpool and the United States via Mississippi. When 2,600-ton *Georgia* whooshed down the ramp towards the Tyne, a workman became entangled in the anchor chains and was incredibly lucky to walk away from the affray with only a broken arm. In January, it was announced the streets of Jarrow were now lighted with gas, and in May, the Ellison schools were opened with children singing hymns followed by a speech by the Bishop of Durham. At the beginning of the year, the foundations were being laid for the rolling mills, the population of Jarrow reached 10,000, hundreds of new houses were built, then there was the minor lawlessness. In late October, local police officers captured Patrick Henry because two months previously he had stolen a syringe and a wooden plane. Discovering he had prior convictions for theft, he was imprisoned for four years at Durham. Following in Patrick's footsteps, fifty-two-year-old Sarah Winship had stolen a shirt in July. Due to also having previous convictions, she was sentenced to twelve months' penal servitude. With the list of petty larcenies fading, what about the murder charge later reduced to manslaughter?

With the rolling mills now in operation, John Conlin worked as an iron puddler. He had left his hometown of Armagh, now part of Northern Ireland, fifteen months previously. Aged twenty-three and single, he was a former Irish militia man who had purchased a spring back dagger from South Shields for 1*s* 6*d*. Neil Fagan, also a native of Armagh, was twenty-five-years of age, and worked at Mr Elliott's Iron Works in East Jarrow. They collected their wages and had the nineteenth-century equivalent of a pub crawl that started on Saturday 24 October and ended in bloodshed at 1 a.m. on the 25th. They spilled out of their fifth bar of the night, The Don Bridge Inn, and various witnesses concluded the men were possibly inebriated, though not intoxicated, and most likely somewhat tipsy.

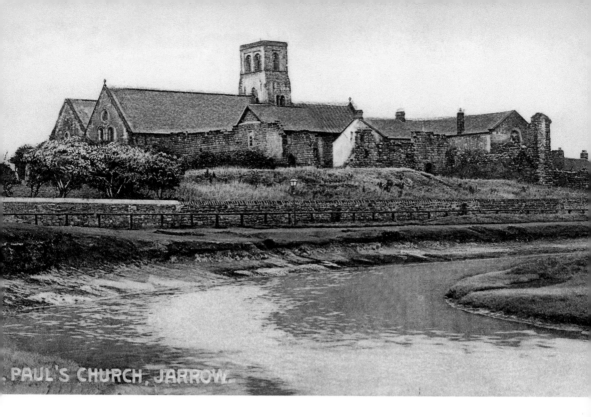

PAUL'S CHURCH, JARROW.

Above: A postcard of St Paul's Church, Jarrow. The Don Bridge Inn rooftop can be seen on the far right of the image. (Source: Kevin Blair)

Right: A blurred photo of Don Bridge Inn, Jarrow, date unknown. (Source: Kevin Blair)

Neil, also known as Ned, was engaged in a heated discussion with Conlin, arguing about something that had happened weeks before. When they fiercely debated who the best fighter was between them, John Grew, a fellow pub crawler who worked at Palmers, intervened, and ordered them to stop quarrelling, pausing to further lecture them under the moonlight. They walked towards the old River Don bridge where their argument escalated and Conlin dared Fagan to approach him.

Spotting the glint of a knife in Conlin's hand, Grew warned Fagan not to approach. Fagan replied, 'Oh, it is only a pipe stopper.' Grew went to speak to another man, and when he turned to the bridge again, a pale Fagan staggered towards him. 'I am stabbed by John Conlin; what a nasty fellow to go and stab a poor fellow in that way,' he said, paling further.

Grew returned to his lodgings, supporting Fagan who struggled to walk. After a few moments and with Fagan unable to settle, he shepherded the injured man home, and while Fagan awaited the arrival of a doctor, John Conlin fled the scene.

After being roused from his sleep, Dr Robert Farrer Thompson, a surgeon at Jarrow, eventually arrived to treat Fagan's wounds. Tragically, the doctors who attended Neil Fagan over the twenty-four-hour period following his stabbing believed his wounds were superficial. In immense discomfort and pain, Fagan lingered until Monday morning. Still resting in his lodgings at Jarrow Church, he passed away at 6:30 a.m. The next day, an inquest was launched at the last pub Fagan had ever drunk in, the Don Bridge Inn, less than twenty yards from the scene of the crime. Headed by Coroner J. M. Farrell, Esq, and assisted by an all-male jury, Police Superintendent Squires was also present while the witnesses were called.

Don Bridge Inn and the Old River Don Bridge, date unknown. (Source: Kevin Blair)

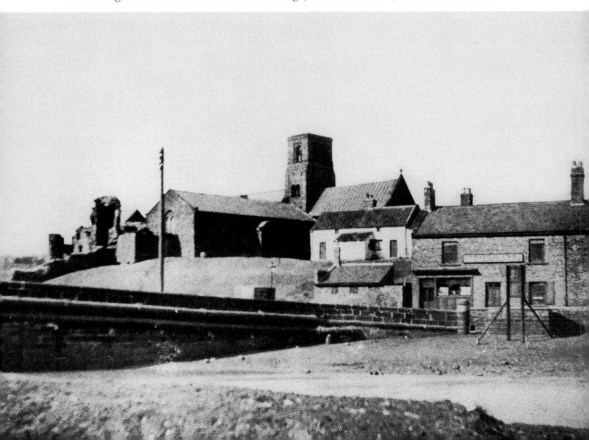

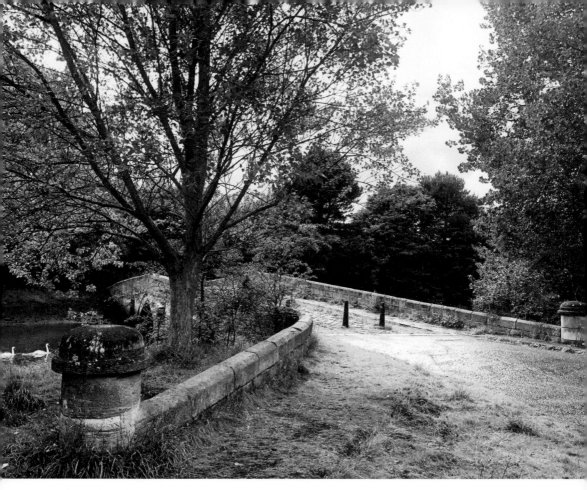

The bridge where the violence took place and John Conlin stabbed his friend Neil. (Source: Natasha Windham)

Ellen Cassidy, another Armagh native who lodged in Jarrow, called the winding street close to the old River Don bridge her home. When giving evidence, she said:

I live at Jarrow Church. I recollect Sunday morning, between twelve and one o'clock, when Fagan was stabbed. At that time, I went out into the street because I was informed John Grew was fighting near the bridge. When I got into the street, I saw Fagan and Conlin pulling one another against the wall, as if in jest. I told John Grew not to allow them to do so, when he replied, 'They are two idiots; I am not going to bother any more with them.' Both their caps fell off. Almost immediately afterwards Fagan turned towards me and said, naming me by name, 'John Conlin has stabbed me.' He began to loosen his trousers; when thinking that he was in jest, I turned away from him and would not look. Fagan then called on Thomas McClusky and said, 'I take you to be witness that John Conlin has stabbed me.' I did not see any blood. Conlin and I once lodged in the same house together. I have heard that Fagan and Conlin differed once before. Conlin at that time wanted to fight, but Fagan declined.

A wrestle against a wall between Conlin and Fagan had turned deadly and another witness, Barnard Murphy, discussed his knowledge of the fatal altercation and answered the coroner and jury's questions.

> I am a labourer and work at Mr Ellison's ironworks, Jarrow. I was on the bridge on Sunday morning, and about four yards from Fagan when he was stabbed by Conlin. Fagan and Conlin had their hands on each other's shoulders, and I went to separate them. The next thing I saw was Fagan coming from Conlin in a stooping position and saying, 'Oh, man, you have stuck me.' He was bleeding from his left side. I then ran as fast as I could to seek a policeman. Afterwards, I saw Conlin near the police station. He was going in the direction of Newcastle. He asked me where I was going, when I replied I was seeking a policeman. I do not know where Conlin is present. I come from the same county as deceased. Conlin also belongs to near the same place. I never heard of Fagan and Conlin having previously quarrelled. I was not in their company that night. I heard Grew say before Fagan was stabbed that Conlin had a dagger in his hand.

Dr Robert Farrer Thompson's evidence furthered the severity of the criminal case against the unaccounted-for John Conlin. Fagan had been stabbed several times.

> About half-past two o'clock on Sunday morning I first saw deceased. He was at his lodgings, upon examining him, I found a wound in the left groin, about two inches below the superior part of the hip bone. There was also a cut near the lower region of the stomach. He did not bleed much. He died on

The River Don Bridge, Jarrow. (Source: Natasha Windham)

Monday morning about half-past six o'clock. I saw him about eight o'clock on Sunday morning. This morning assisted by Drs Ridley and Huntley; I made a post-mortem examination of the body. Externally there was great discolouration about the lower part of the abdomen. In the left groin there was a vertical incised wound an inch in length, extending obliquely to the right, and backwards fully five inches, passing through the ileum and cutting also a portion of the mesentery, and allowing an escape of the contents into the peritoneal cavity, producing peritonitis which was the cause of death. All the other contents of the abdomen and chest were normal. There were no injuries to the head externally. He appeared a healthy man. The wound corresponded with the cut in his trousers and shirt.

With Fagan's bloodied clothes paraded through the room by Police Inspector Rogers and shown to the jury, they promptly delivered the verdict without hesitance. With Neil Fagan's death ruled a murder, a manhunt was launched by the County Durham Constabulary that had begun in Jarrow and rapidly circulated across the country in the form of letters sent to police superintendents with a detailed description of the wanted man.

The description consisted of: 'Aged 23, 5 ft 6, dark brown hair, brown whiskers meeting under the chin, round full face, ruddy complexion, small marks from recent scratches on nose, stoutly built, in knee'd in the left leg. Last seen wearing blue pilot jacket, dark cloth vest and trousers, cloth cap with peak, wellington boots, and had on two white cotton shirts, one of which was supplied by the militia and believed to be marked.'

The coroner had issued an arrest warrant for Conlin's capture, however, he remained at large until January 1864. Police Superintendent Squire continued to send dozens of letters to police forces across England to remind them of Conlin's missing status. He discovered a clue, possibly from Conlin's friends still residing in Jarrow, that pointed to the wanted man being concealed in the East Midlands. He sent word to Police Superintendent Ronayne in Alfreton, Derbyshire, who suspected a mason's labourer employed since November could be the runaway Irishman. Venturing to the heart of the village, the sleuth-like Ronayne discretely investigated further and believing his suspicions to be correct, he approached the labourer and charged him with being the wanted Irishman John Conlin. The labourer shook his head and denied knowledge of the murderous deserter. 'My name is John Hare,' he said. Immediately taken into custody, he stubbornly stuck to his story. 'I'm John Hare.'

Ronayne trusted his own instincts and wrote to Police Superintendent Squire with jovial pleasantries and news of the capture. With congratulatory words exchanged between both police superintendents, the labourer left the village two days later under the custody of Ronayne. Their destination by steam train was Gateshead railway station, a trip of 145 miles. They arrived in the evening and

the moment they stepped off the train the labourer admitted his identity – he was John Conlin of Armagh, and it was true he had stabbed Ned Fagan in Jarrow.

Police Superintendent Ronayne of Alfreton handed Conlin into the custody of Jarrow's Police Superintendent Squire, who then escorted the prisoner to Durham Gaol. On Tuesday 1 March 1864, Conlin was indicted for the manslaughter of Fagan and appeared at the Durham Assizes. The prosecution placed into evidence Conlin's letter written to his cousin while held at Durham Gaol. In one of his many paragraphs, he admitted stabbing Fagan and claimed he had only used the knife to defend himself after his opponent had struck him twice across the face. Found guilty of manslaughter, John Conlin was sentenced to seven years' imprisonment for the slaying of Ned Fagan. A seven-year prison sentence for manslaughter in a world where a habitational thief earned a five-year imprisonment could be considered absurd, insulting, or merely mystifying, but if you ever retrace the steps of those intoxicated, sparring men who spilled out of the Don Bridge Inn that terrible night, pause along the trail just before the bridge meets your toes and imagine the violence the cobbled stones under your feet witnessed on 25 October 1863.

The view today from the foot of the old bridge. (Source: Natasha Windham)

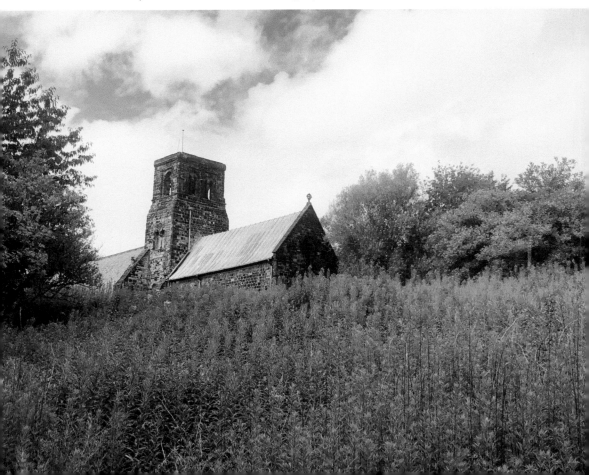

CHAPTER 3

SHOT THROUGH THE HEART

In the turbulent town of Jarrow by the bustling and busy Tyne, Patrick Convery, aged thirty-six, spent November 1868 harbouring a destructive jealousy against his wife, Ann Charlton, after she had befriended twenty-five-year-old John Docherty. Both Patrick and John were fellow Irishmen who lived on Palmers Row. It was a street lined with two-storey homes with families that had grown used to the sounds of the nearby shipyard. The houses contained no more than two cramped bedrooms with separate entrances. Ann Charlton, a distant cousin of John Shafto Wilthew, had lost her first husband and two children to early deaths. When Convery had lodged in the home she shared with her mother on Palmers Row, they had eventually married. The other lodger in the house, John Docherty, had been sent away by Ann's mother after tensions had risen between the two men.

Patrick worked as a labourer at Palmers and eighteen months previously laboured as a fireman on Palmer's screw steamer *The Lupton*. Known as a quiet man and an excellent shot with both pistol and gun, he often practised at shooting galleries in Jarrow and had won a leg of mutton as a prize months before the violence rocked Palmers Row. Convery and his wife were firm friends with

Patrick Convery had worked at Palmers Shipyard. Date unknown. (Source: Kevin Blair)

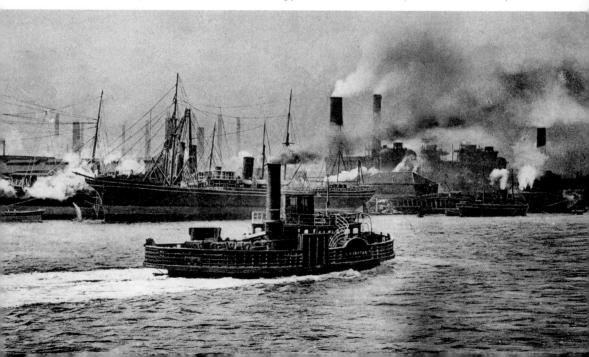

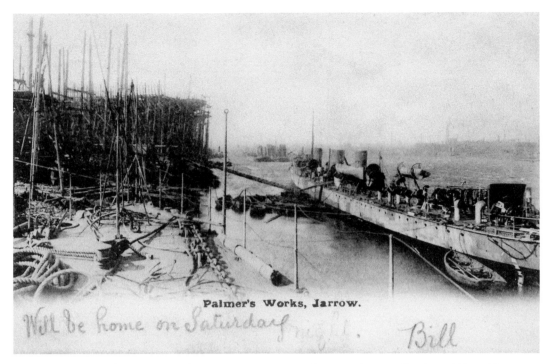

Palmer's Works, Jarrow.

Will be home on Saturday night. Bill

A postcard of Palmers Works, Jarrow. (Courtesy of Kevin Blair's collection of Tyneside photos)

Mr and Mrs Harney, who lived four doors down from them. John Docherty, who had resided in Jarrow for five years and worked at the rolling mills, had taken lodgings at the Harney household. Jealousy continued to flourish in Patrick's mind like wildfire and he had taken to both drink and beerhouses throughout Jarrow on the afternoon and evening of Saturday 28 November 1868.

At 10 p.m., Patrick was walked home by a Mrs Watson. When they passed the Harney house on Palmers Row, he saw his wife, Ann. The wildfire turned into an inferno, and he fought violently with her, striking her several times until she fled back to the Harneys. Patrick followed Ann and an argument ensued between him and Bridget Harney as he accused her of encouraging his wife to visit the house. While she demanded to know why Convery had struck his wife for visiting her home, John Docherty overheard and asked Patrick if he had struck Ann because of him. When Patrick confirmed that was his reason for attacking Ann, John punched Patrick and sent him crashing into the table. A scuffle broke out and the women separated the warring men after John pinned Patrick to the bed and said, 'If I thought it worth my while I could choke you before I let you up; but I would not have the sin of you on me.'

Convery returned to his dwellings where Mrs Watson and another witness watched him remove a pistol from a box. 'This is my box, Mrs Watson,' he said

and carefully examined the pistol, checked it was loaded, put it in his breast pocket and left the house. Twenty minutes later, he approached the back of the Harney home and shouted for Docherty to come out and fight. Opening the door, Docherty asked if Convery wanted him. Convery answered, 'Yes, you are the very bastard.'

When Convery continued to shout, making a scene, and calling for Docherty to leave the safety of the house, Docherty called from the doorway, 'Don't shout for any man, for I am the man for you.' Held back by Bridget Harney and Mrs Bishop, they attempted to stop the fight from escalating by telling Docherty that Convery was not worth striking again.

'Come on! Come on!' Convery shouted to Docherty, determined to lure him into a murderous and premeditated plot. 'Come on, you bastard, if you are a man.'

'No, not tonight; he's going back to his lodge,' Bridget had stated firmly to Convery.

'You durst not come, you bastard,' Convery had taunted.

Docherty broke away from the women and ventured into the back lane to fight Convery, who already had his hands in the breast pocket of his coat. Seven feet from his nemesis, Docherty raised his fists and steadied himself for a fair fight, but Convery pulled the pistol from his pocket and deliberately fired.

Bridget Harney had been watching the two men and saw a blaze of light and then heard the crack of the shot. She instantly ran forward to check on the stumbling Docherty. The small, leaden bullet had met its target with painful precision and entered the centre of his chest. 'Stop him, Hackett; he has shot me through the heart!' Docherty cried and tried to run after his would-be-murderer. He faltered and turned to Mrs Harney when the adrenaline started to fade. 'Take hold of me, Bridget. I am shot – shot through the heart. There's the man that did it, take him.' He was carried home by several concerned neighbours who had left their own homes when the commotion had started.

Thomas Hackett, with the assistance of Thomas Watson, sprinted after Convery and captured him on the back lane towards the ferry landing and just past the gates of Palmers Shipyard. Superintendent Salter charged Patrick Convery with wilfully shooting Docherty. Messages were sent to local medical men and Dr Whamond examined the body of Docherty at the home of the Harneys and pronounced life extinct. The authorities soon discovered a small box containing gunpowder and small caps close to the lane where Convery had fired at Docherty, though the pistol was missing.

At the local police court, Convery admitted his guilt but said he had great provocation for shooting John Docherty dead. The inquest into the death was held at the Golden Lion Hotel, Walter Street, Jarrow, two days after the shooting. After they were sworn in, the jury viewed Docherty's body and listened to the evidence. A thirteen-year-old boy named David Gillespie found the pistol hidden along the back street of Palmers Row and handed it to the police. The jury were

shown Docherty's blue flannel shirt saturated with blood and the bullet-shaped hole was pointed out to them. Superintendent Salter claimed Convery had first denied his involvement with the words, 'I never had a pistol and I have murdered nobody.'

On the day of the inquest, the evidence was read to Convery and when asked if he had shot Docherty, he replied, 'Yes, sir, it is quite correct.' He then questioned the other witnesses with a statement that suggested Docherty had run towards him in a threatening manner. Every witness denied Convery's version of events. The jury retired for three minutes and returned a verdict of wilful murder against the paled, tearful, faint and trembling man. Described as 'proportionally built with dark hair, dark whiskers and a determined face whose features are by no means repulsive', Patrick Convery was committed to trial at Durham. Despite countless witness testimonies, the violence shown towards his wife and the premeditated nature of the murder, the jealous, murdering sharpshooter Patrick Convery was found guilty of manslaughter and sentenced to twenty years' imprisonment.

A snapshot of Dartmoor prison, where Patrick Convery was sent to. *Illustrated London News*, 2 January 1897.

CHAPTER 4

NOW, YOU OLD BASTARD

It was 1879 and life in Jarrow continued to be chaotic and unsettled for many of the inhabitants. In Stanley Street, New Year's Day left Dinah Huart temporarily without a home after she had refused to cook her husband supper. John Huart, a ship rivetter, had returned with money that he neglected to share with his wife. After he had left the house with one of their sons, John reappeared at 1 a.m. and asked where his supper was. Dinah, furious that John had sent their son home at 10 p.m. with ten shillings and a piece of meat, stated if she was not qualified to buy the meat, she certainly would not be qualified to cook it. John seized her by the shoulders and guided her out the house. He then locked the door and refused to allow her back into the safety and warmth of their home.

Dinah walked the short distance to the police station on High Street and asked for aid in convincing her husband to let her back inside the house. Sergeant Waugh escorted her to Stanley Street but even he could not persuade the stubborn man to unlock the door. Dinah spent the night with friends, and when the case was brought to the local borough police court, John launched into a passioned speech about why he was justified in his actions. He said his wife was a delinquent because she refused to wash his clothes or cook his meat, she often ran him into debt, and the house was filthy because she would not clean it. The Bench dismissed the case, though chose to bound John over to keep the peace for six months. Before they were shooed from court, the mayor, Alderman Huntley, lectured Dinah on her appalling conduct because how dare she refuse to cook or clean for her husband.

On the same day, the court also presided over a vicious wounding case involving an inebriated George Young of Pearson Place and his long-suffering wife. They had spent the remaining days of 1878 embroiled in a war after he had accused her of taking two shillings from his drunken pocket. She denied it, and he knocked her to the floor. Her son told her to give George the two shillings just to keep the peace and she once again denied taking the money. She found a half-crown and gave it the boy to fetch change. She wasn't on her feet for long. George knocked her down again and she felt a sharp pain to the side of her neck as he struck her. Her son pulled George off her and she was covered in blood. George had stabbed his wife in the neck. She fled to the police station, then to Dr Bradley, where her wound was treated. When arrested, George said, 'It is alright, let her make a charge against me.' Dr Bradley stated the wound to the woman's neck could never be considered a dangerous one. Yet, George had still stabbed his wife while drunk and disorderly. He pled guilty and was sentenced to six months' hard labour at Durham Gaol.

It remained 1879, and Police Constable William Craggs had turned thirty-five years old. In the few years he had been based in Jarrow, he lived with his wife Jane and their three children at No. 26 Ellison Place. Since his arrival in the turbulent town, he had policed the borough with courage and was assaulted several times in the line of duty, often attacked by crowds in attempts to save their friends from arrest. Left with a torn cape, bruised body, and using a truncheon to chase the drunken assailants away, he became a force of nature with a critical eye for criminality. During his evening patrol, in June of that year, he walked through the back of Station Street when he spotted Edward Lannigan indecently assaulting two young girls. When Lannigan heard Craggs' shout he immediately fled the scene with the infuriated police constable chasing after him. Eventually, PC Craggs captured Lannigan and marched him to the police station on High Street. The child abuser was swiftly sentenced to six months' hard labour at Durham Gaol.

With firefighting, crime detection and an active family life weighing heavily on him, it was now 1883. A twenty-year veteran of the Durham Constabulary whispers of money worries followed PC Craggs' every step, and he secured a second job as a nightwatchman. Craggs' superiors discovered his night-time

THE FIRE.
HONOUR TO WHOM HONOUR IS DUE.
To the Editor of the Jarrow Express.

SIR,—Might I be allowed the use of your columns to put certain persons right with regard to what took place at the fire in Mr T. Medd's warehouse, on Saturday night last. The persons who discovered the fire, and those who first made the attempt to extinguish it, have been almost entirely over-looked in the reports which have gone forth to the public. All that has been said with regard to the police is perfectly true, and more might be added, for a cooler man than Superintendent Harrison I never saw on such an occasion. But surely there is no need for the extravagant praise which has been bestowed upon the Corporation Fire Brigade. The first persons on the spot were the police and the men who procured the hose from the yard; and the Borough Brigade, which only numbered two (there was another, but he was—well, in a happy condition), did not arrive till some ten minutes after the men had the yard hose in working order. Then look at the conduct of the powerful (?) brigade; they saluted P.C. Craggs with a stream of cold water when he came to the window to breathe, and instead of playing on the burning materials within, took deliberate aim at the two police-men on the balcony. So determined were they in the matter, that when a policeman interfered one of the Corporation brigade threatened to report him. Well, the fire was fortunately got under, for which the volunteers—especially Sergt. Fletcher—and the police are to be thanked. Had the brigade under Sergt. Fletcher not arrived when they did, the probability is that the fire would have extended to the whole building. I need not go into details, for it will doubtless be fully reported in your paper, but as the borough men have claimed all the honour, I thought it right to send you the comments of AN EYE WITNESS.

A letter written to the editors of the *Jarrow Express* and printed on 22 August 1879 mentioned PC Craggs. A fire had broken out at a pawnbroker's on Walter Street. In the dead of night. Sledgehammers borrowed from Palmer's yard were used to smash the shutters off the windows to gain access to the fire. Great crowds gathered on Walter Street to watch.

activities and Chief Constable White demanded he resign from his position as a nightwatchman immediately and accused him of neglecting his police duties. He refused because his second job earned him four shillings for every shift he completed, and in November he was removed from his duties at Palmers Works and replaced with Police Sergeant Thomas Best. The arguments and disapproval rumbled into January 1884. By the 4th, Craggs had stepped away from his second job and invited Sergeant Best to his home. Furiously blaming Best for stealing his position at Palmers, the discussion descended into disorganised chaos when Craggs hurled a torrent of abuse at Best and threatened his life. Fearing for his safety, Best returned to High Street and reported Craggs' conduct to Police Superintendent Joseph Scott. Believing it to be a serious breach of discipline, Scott reported Craggs' behaviour to headquarters and because he had previously been fined for misconduct, Chief Constable White sent a letter to Scott three days later requesting Craggs resign from the police force and return his uniform. When the letter was shown to Craggs, he refused to resign from the force and would not return his uniform. Police Superintendent Scott dismissed him and when the uniform wasn't returned, Craggs was summoned to the County Petty Sessions in South Shields. He was fined forty shillings and bound over to keep the peace. He arrived at the police station the next day with Mr Pattie, a Jarrow butcher, who stood bond for him. Craggs handed back his uniform, truncheon and whistle.

After dismissal from his position as a police constable, William Craggs had now lost access to his pension. He had money worries, a wife and three children to support, his audible battles with the local police force were frequently gossiped about in the streets of Jarrow, and with his mental health eroding, he turned to drink. It was now Wednesday 16 January, a day after Craggs had returned his police uniform, and at 5 p.m. he was seen loitering outside the gates of Palmers Works dressed in dark clothes, an overcoat and a black felt hat. The manager of the rolling mills, Mr Allison, said Craggs was in good humour. They spoke for a short time until the men had begun to leave the engine works while Sergeant Best stood beside the open gates talking to the gate watchman James Richardson.

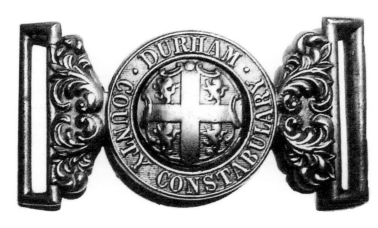

Victorian Durham Constabulary belt fastener. (Courtesy of Malcolm Smith)

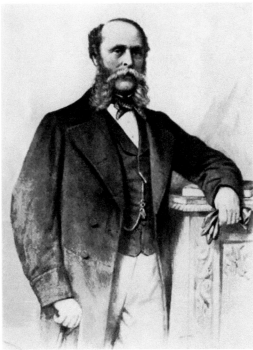

Above left: Book of regulations for an officer of the Durham Constabulary. (Courtesy of Malcolm Smith)

Above right: Lt Col George Francis Smith, the Chief Constable of Durham Constabulary who ordered Craggs' resignation.

Suddenly, Craggs rushed towards Best with his arm outstretched and a gun in his hand. 'Now, you old bastard, I have got you at last!' he declared chillingly and fired the weapon.

The bullet entered Best's right cheek and caused catastrophic injuries to his mouth, blasting through his top lip and shattering his front teeth. Craggs watched Best collapse to the ground and fired a second bullet, which lodged in his victim's shoulder. He fired again and a panicked Best raised his arms to shield his face. The third bullet settled in Best's arm and before any further murderous intent could be unleashed on the injured police sergeant, James Richardson snatched a large stick from the ground and ran at Craggs in a brave attempt to force him to flee. Craggs dodged the attack and turned his quest for revenge on Richardson instead. He raised the revolver and held it against Richardson's head. Realising how close to death he was, Richardson dropped to the ground as the sound of the gun firing followed moments later. Craggs perhaps believing he had killed both men turned and ran in a bid to escape. Richardson scrambled to his feet and chased after Craggs. The ex-police

Palmers' cranes were a familiar sight at Jarrow thanks to the shipbuilder's yard. (Source: Kevin Blair)

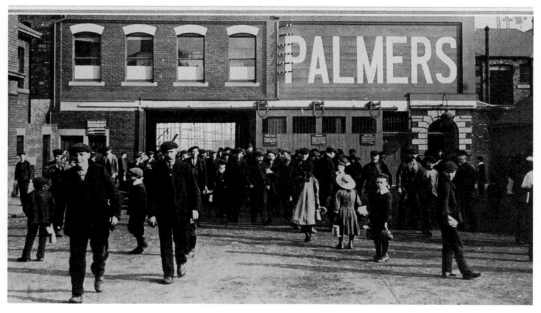

Palmers Shipyard gates, *The Sphere*, 1910.

constable and newly crowned attempted murderer realised he was being followed and skidded to a stop, firing the gun in the direction of Richardson again. Ducking down, the gatekeeper decided to let Craggs escape. As the winter's night drew darkness and a bitterly cold wind, Craggs fled through Palmers Works and along the Pontop Railway.

Sergeant Best's grave injuries were tended to by Doctors Bradley and Blair, who carefully dressed the wounds before escorting him home with the help of several of his police colleagues. Word had now spread about Craggs' murderous plot that had mutated into several minutes of frenzied violence at the gates of Palmers Works. Craggs' former colleagues were determined to find him, and information was telegraphed across the district with trains stopped and searched. A light description of Craggs was also circulated across the borough: He was a stiffly built man of medium height with a black beard and a black moustache. As midnight approached, Craggs had not been apprehended and Superintendent Scott was concerned he had slipped out of the area, but at 9 a.m. the next morning workmen on the River Tyne spotted the body of a man lying on the rocks between the Tyne Lead Works and the New Staiths. Fifteen yards from the body was a black felt hat.

The police were instantly sent for and PC Cooney of Hebburn arrived at the scene and spotted the muzzle of a gun peeking from the dead man's pocket. He removed the weapon and identified the body as William Craggs. The body was

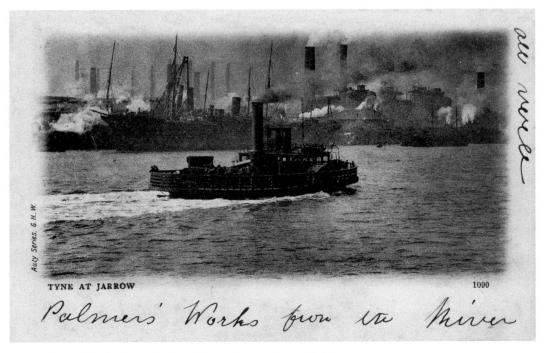

Palmers Works from the River Tyne. (Source: Kevin Blair)

removed to the deadhouse and Craggs' clothes were searched by Police Inspector Snowdon. Fifteen bull cartridges, a pair of gloves, a pencil, a handkerchief and loose change were discovered in the pockets of the coat. The watch found in Craggs' waistcoat pocket had stopped at three minutes after five o'clock the previous evening, which they speculated was the time of death. The police believed Craggs had thought he was responsible for Sergeant Best's death and decided to end his life by jumping into the River Tyne. The inquest into the death of William Craggs lasted mere moments and the jury returned the verdict of 'found drowned: but there was no evidence to show by what means the body came into the water.' They also concluded the police had not mishandled the disciplinary process surrounding Craggs' dismissal from the police force then suggested his behaviour was due to temporary insanity. The public backlash was swift and condemned the police, and Superintendent Scott released a statement to the people of Jarrow reassuring them they had not treated Craggs harshly. He informed the public Craggs had been fined for breach of regulation eight times and it had been the Chief Constable's decision to dismiss the errant officer. His words failed to quiet the backlash and on Sunday 20 January 1884, William Craggs was treated to a hero's funeral. It is suggested it was one of the largest crowds to ever join a funeral march in Jarrow. Dense masses filed through the streets, watched by thousands of eager faces desperate to capture a glimpse of the coffin adorned by three wreaths and carried by his friends in the procession. Leading the march was the Hebburn Colliery Brass Band playing the mournful tune of Dead March.

JANUARY 11th, 1883.—Great Liberal Meeting in the Mechanics', banquet to the Solicitor-General (Sir Farrer Herschell).

MARCH 17th, 1883.—School Board Election.

APRIL 26th, 1883.—The Horse and Cart Steam Ferry was launched and named the *G. H. Dexter*, by the Mayoress (Mrs Dexter),

JULY 16th, 1883.—The Horse and Cart Ferry commenced to ply between Jarrow and Willington Quay.

OCTOBER 25th, 1883.—A portrait of Ald. C. M. Palmer, M.P., First Mayor of Jarrow, was presented to the Town Council by his wife, Gertrude Palmer.

DECEMBER 19th, 1883.—Wallsend Café opened by Mr Burt, M.P.

DECEMBER 21st, 1883.—New covered Market in Back Ormonde Street opened.

JANUARY 16th, 1884.—Sergt. Best shot at and wounded by Ex-P.C. Craggs, who, immediately afterwards, jumped into the river and was drowned.

JANUARY 23rd, 1884.—Wesleyan Mission Chapel in Knight Street opened.

MARCH, 1884.—Opening of Liddell Provident Dispensary.

MARCH 28th, 1884.—Opening of Congregational School Buildings, Sheldon Street, cost £1,380.

JULY 14th, 1884.—The Royal Assent was given to the "Jarrow Improvement Act, 1884."

AUGUST 21st, 1884.—The Albert Edward Dock was opened by H.R.H. the Prince of Wales.

NOVEMBER 21st, 1884.—The Ferry *C. M. Palmer* was added to the service between Jarrow and Willington Quay.

Murder mixed with the mundane, *Jarrow Express*, 3 January 1890.

Thankfully, Thomas Best survived the atrocious attempt on his life, and unfortunately, the death of William Craggs left his widowed wife raising their children George, Ralph, and Hannah alone. She never remarried; her children remained faithfully by her side until they wed. Only Ralph Craggs resurfaced negatively in the newspapers and caused quite a scandal in 1916 when he was summoned to court by his wife Eleanor for persistent cruelty. On previous occasions he had thrown a plant pot at her, left her body black and blue, and she had once fled the house to fetch a policeman after fearing for her safety. Their marriage was beyond the scope of unhappiness, and he had informed her he would not 'give the other woman up'. When she accused him of sleeping with another man's wife, he had held her by the throat. She also informed the court her husband returned to their home at midnight with another woman. She had even caught them cuddling on the sofa. Ralph admitted putting his hands to his wife's throat but denied any snuggling had taken place on his sofa. He claimed he had refused to order the other woman from the house to stop the neighbours gossiping about his crumbling marriage or the potential affair. The local Jarrow magistrates took a dim view of Ralph's conduct and issued a separation order and granted Eleanor thirty shillings per week from her husband's wages. Alderman Penman, the chairman of the bench, remarked that he was sorry Mrs Craggs hadn't requested a greater share of her husband's salary.

CHAPTER 5

DO YOU KNOW THESE STREETS AND STORIES?

It is time to take a tour of the Jarrow of the past. After all, it was still the wild west of the North East. Resilient with their weapons of choice, normality meant petty crimes with hefty sentences in the town where rough bricks, water or coal rakes were used to strike, puncture and bruise. It was the town where, in November 1874, Robert Cassidy had ferociously attacked Ellen Moran in a property on Dog Bank Row. Later admitting to being 'mad with drink', Cassidy said he could not remember the attack. He lodged with Ellen and had brought a woman home. When the woman had pawned something that belonged to Ellen, Ellen had slapped the woman, and the woman had smacked Ellen back. In a drunken rage, Robert seized Ellen by the hair and dragged her across the floor. On his arrival, PC Jackson was met with a locked door and had to watch through the keyhole while Robert continued his attack. Finally gaining entry to the room, the police constable found both Ellen and the floor covered with blood. The magistrates were disgusted with Robert Cassidy's behaviour and sentenced him to six months' imprisonment with hard labour.

Perhaps you have walked the same route as Robert Johnson, who had asked PC Price for his assistance on Grange Road. They strode to Croft Terrace where Johnson had quarrelled with his father-in-law. As the argument flared once more, the police constable tried to separate the two men and Johnson retaliated by punching Price in the head and knocking him to the floor. For his flying fist, Johnson earned himself a 40s fine.

Now imagine you caught a train to Newcastle and purchased several firearms. In 1878, Peel Street, Jarrow, would once again witness a would-be murderer with a gun. William Telford, who would later say, 'It's alright, I did it', had attempted to murder his stepson on the doorstep of the family home. On the 21 September, and upset over his broken marriage, William had visited Pilgrim Street in Newcastle and purchased two pistols, one revolver, one box of bullets and a flask of gunpowder. On his return to Jarrow, between five and six in the evening, he went to No. 7 Peel Street and knocked on the door. His twenty-six-year-old stepson, George Greenfield, answered and asked him what he wanted.

When William complained he had yet to remove all his clothes from the home he once shared with his family, George had replied, 'It is your own fault.'

'It is going to be a bad job,' William seethed and fired a pistol at George.

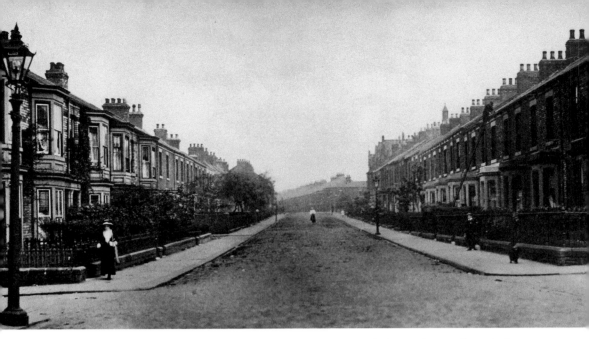

Croft Terrace, Jarrow, the scene of the skirmish between father-in-law and son-in-law. (Source: Kevin Blair)

The bullet lodged in George's abdomen and he collapsed. A group of men nearby chased after William and held him until he was arrested by PC Laycock. When charged with attempted murder by Superintendent Harrison, William had answered, 'Yes, it's alright, I am not going to deny it.'

On the date of the trial, the jury were lenient because William's defence lawyer sewed a story with a thread that claimed the pistol was only fired to frighten the stepson. However, why had George attempted to gain entry to his former home with three newly obtained guns in his pocket? The judge believed William had intended to murder George and sentenced him to ten years imprisonment.

Jarrow was the town where, under the influence of drink, Peter Young, on 17 August 1896, drove a stolen pony and trap in the direction of Western Road where the railway lines once crossed. He travelled at a speedy pace, and despite a loud shout from railway watchman James Guthrie, Young lashed the horse with the whip. The horse galloped over the crossing as a row of wagons thundered towards them. The accident was catastrophic, leaving the horse in a collapsed state with three broken legs. Young jumped from the trap and ran away. The horse was destroyed, and Young was arrested by Sergeant Bousfield.

'I emphatically deny it, it was an accident, and I do not know whether the railway or I was to blame, I did not attend to steal it,' Young had told the sergeant.

Apologising for the trouble he had caused and the accidental death of the horse, Young said he was very sorry he had stolen the pony and trap from the Wellington Hotel, South Shields. Despite his offer to compensate for the value of the horse, he was remanded in custody for seven days. In his second appearance in court, he was dismissed without charge after the police decided his crime was simply a drunken spree.

A DISGRACEFUL CASE.

Margaret Costello, married, 35, Stanley-street, was charged with using obscene language in the public streets, and with assaulting Catherine Gillon on the 12th inst. Complainant said she was going to bed, when she heard a noise outside. She went out, when she met the defendant, who at once seized her, and charged her with having her husband in the room with her. She called her a b—— h——, and pulled her hair. Catherine Gillon, daughter of the complainant, corroborated her mother's evidence. She went down stairs when she heard her mother screaming, and saw the defendant stricking her, giving her mother a black eye. Defendant denied the charge, and said the last witness was not present. P.C. Feasey proved the charge of using obscene language. He was on duty in High-street, when he heard a disturbance in Dog Bank row, and on going there saw the defendant going into Stanley-street, where she was using very bad language. P.C. Stroughair corroborated the last witness, and said there was a large crowd. Defendant denied the charge. Mrs Gillon was with her husband continually, and she had had two children by her (Mrs Costello's) husband. On the night in question she went to complainant's house, where she heard her husband talking to Mrs Gillon; she asked for him, and Mrs Gillon put her out. Several witnesses were called in defence. A young man named Burk swore he saw Costello come out of the house, and gave it as his opinion that he had been there all the time. Complainant's daughter, recalled, said Costello was not in the house that night. Patrick Costello, son of the defendant, said he was at the complainant's house, where he heard his father's voice. He waited, and saw his father come out about five minutes after the row. Defendant said she could not say she struck her. She was between the door, and they struck her with a poker. Her husband had left her through this case, and she had eight children to support. Both cases dismissed.

A 'Disgraceful Case' on Dog Bank Row, Jarrow, where two women fought over the same man. *Jarrow Express,* 18 October 1878.

Ever lived beside a nosey neighbour? Poor Elizabeth Sainty, on High Street, struggled with the ever-snooping Mary Patterson. In July 1882, after Patterson had watched two men enter Elizabeth's home, she informed the estranged William Sainty of his wife's conduct. She constantly accused Elizabeth of improper behaviour as a wife. 'It did not look well to see men going into the house in the absence of Mr Sainty. Mr Newlands would not like his wife visited that way,' she said, and caused laughter in the local Jarrow Police Court.

Newlands, the defence lawyer for William Sainty, was tasked with addressing the bench in the hopes William would avoid a grave sentence. After learning of his wife's behaviour, and despite living separately for two years, William had visited the address and struck her several times with a fire poker. Elizabeth's arms were black and blue, and she stated she was afraid to live with him and requested a separation order. She denied any sober men had visited her. She also refuted the scandalous rumour men with the surnames of Holmes and Coulson had left her home when drunk.

William admitted selling all the furniture from the home he had once shared with his wife, and when the bench asked him how he expected his wife to live, he had furiously bellowed, 'Let her go and live by her own prostitution as she did before

Jarrow High Street today. (Source: Ewen Windham)

I married her!' Mr Newlands explained Elizabeth had kept bad company in South Shields before she married. Whilst the sentence was announced, William leaned over and complained to Newlands, 'You'll not give me a chance at all, old man.'

William was fined 5s and costs for the brutal assault on his wife. When he was also ordered to pay 3s a week towards the maintenance of Elizabeth, he became irate, shouted at the mayor, and had to be dragged from the courtroom. The bench informed Elizabeth the separation order had been granted and the 3s payments would only be enforced if she led a pure, moral life.

Spare a thought for the barman at the Golden Fleece on Ferry Street in March 1891. While he served drinks, a fight had erupted between five men. Before the barman had a chance to calm them with his stern tone, a glass was thrown and collided with the back of his head. One of the brawlers, James Hand, with his intoxicated mind cheering him on, had decided to leap over the bar to punch and kick the unsuspecting barman. By the time PC Aitchison arrived, even he was attacked several times by Hand's fists and boots when he attempted to arrest the violent, drunk and disorderly boozer. James Hand was fined 2s 6d and costs for the drunkenness and 10s and costs for the lengthy and unprovoked assaults.

VESSEL BLOWN UP OFF JARROW SLAKE.

A MAN KILLED.

Yesterday morning, about half-past eight o'clock, a serious explosion occurred on board a wherry lying off Jarrow Slake which was laden with ammunition for the Italian war vessel *Piemont*. There were three men and a boy in the service of the Elswick Co. on board, named John English, fitter, of the Elswick Ordinance Department, John Wakeham, chargeman, James Dewdney, employed by the Elswick firm as passing inspector, and John James, 15 years of age, all belonging to Newcastle. Dewdney was blown to pieces. On recovering the trunk, both legs and one arm were missing. The boy James was severely burnt about the face, hands, and body; and Wakeham had his right hand burnt, and his hair and whiskers singed. The two latter were taken to Jarrow Memorial Hospital, where the boy was detained and is to-day progressing favourably, but Wakeham, after having his injuries attended to by Dr. Smellie, was able to return to the scene of the accident. The South Shields river police were soon on the spot, but it was found impossible to extinguish the flames, and the wherry was scuttled and sunk at the buoy to which it was moored.

THE INQUEST.

Last night, Mr Graham, coroner, opened an inquest at the River Police Station, Mill Dam, South Shields, respecting the death of George Dewdney. The only witness called was Edward Lowrie, the master of the wherry *Fanny*, on which the explosion occurred. He stated that he went on board the craft at eight o'clock that morning, and saw the deceased, along with Mr English, Mr Wakeham, and the boy James, in the hold. The boy was carrying powder from a cask with a small copper scoop to the men, who were filling projectiles with it. Witness went forward to the bow of the wherry, and at twenty-five minutes past eight o'clock there was an explosion. He immediately jumped overboard, and swam ashore. He afterwards assisted in the removal of the injured persons. The inquiry was adjourned till Wednesday next.

Right: In an escape from crime: a deadly explosion occurred close to Jarrow Slake. *Jarrow Express*, 4 October 1889.

Below: J. D. Rose's photo of Jarrow Slake with battleship HMS *Sapphire* and the isolation hospital in the background.

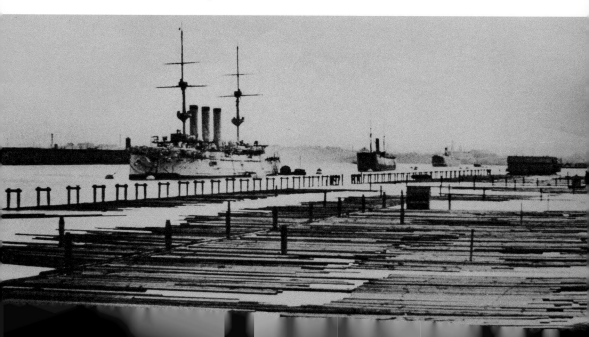

THE TWELFTH OF JULY.

RIOTS AT JARROW AND HEBBURN.

Saturday last, being the 12th of July, the Orange-men of North Durham, including those of Jarrow Monkton, and Hebburn, held a demonstration at Sunderland. For some years the observance of the 12th has passed off very quietly as far as Jarrow is concerned, and it was thought that the old animosity of the parties had almost died out. Consequently it was not expected that any disturbance would have taken place this year. As arranged, about 300 of the brethren met at Monkton, where a procession was formed, headed by a band of music. The intention of the processionists was to parade the streets of Jarrow previous to taking train for Sunderland, where the event of the day had to be celebrated. As the procession neared Jarrow by way of Monkton-road, the people flocked to the street ends to look at the gay sight, all, or almost all in the procession wearing the orthodox coloured scarfs, whilst the insignia of the brotherhood were also borne aloft, the procession being lively with the banners, &c., peculiar to the order. All went quietly enough till the pro-cession reached High-street, where the band struck up. Beyond a few groans and shouts, no hostile movement took place amongst those who followed the procession till Ferry-street was reached. This is a locality where a large body of Catholics reside, and as a consequence, the mob which had gathered round the procession consisted largely of that element. Whilst here, a few of the Orangemen, who were apparently a little under the influence of drink, most unwisely gave a cheer, a proceeding which instantly roused a few of the women belonging to the other party. The men were just leaving the shipyard and different factories at the time, which caused the crowd to swell to greater proportions, and a scene of indescribable disorder took place. Stones and other missiles began to fly, and sundry hand-to-hand fights took place. Happily the police were on the spot, and at once dashed in amongst the mob, and managed to hurry forward the procession, and keep back the crowd in a degree. As the route to the station lay through Ormonde-street, the main business street of the the town, the alarm of the tradesmen may be imagined, for by this time the crowd of combatants and onlookers could not number less than 5,000, and large stones, &c., continued to be thrown at intervals.

arrival of the Orangemen, they were forwarded to Hebburn, accompanied by a strong force of constables. Here an excited mob awaited the train, and the ap-pearance of the Orangemen was the signal for groans and yells. From the Station Hotel to the Argyle Hotel (the Orange lodgeroom) was one vast crowd, completely hemming in the Orangemen and their protectors. Stones were thrown in large numbers, and several of the constables were struck, including Inspector Harrison, Sergt. Elliott, and P.C. Maughan. On nearing the Argyle Hotel the fight became furious, the police behaving in a manner which re-flects the greatest credit upon them for pluck and forbearance. The sticks of the combatants were wrenched from them by the policemen, and thrown over the stone wall into the plantation, and at length the whole of the Orangemen gained the shelter of their meeting-house. For a time the mob continued outside, and several isolated fights took place, but the presence of the policemen kept them well in check. At one time a few of the Catholic party gained admittance to the Argyle Hotel, and a free fight ensued. Glasses, pots, &c., were freely used, and some ugly cuts was the result. Inspector Harrison, Sergt. Elliott, and P.C. Maughan entered the house, and with the assistance of the Orangemen, succeeded in ejecting the other party, some of whom retired much the worse for their venturing inside. Most of the Catholic party being residents of the Quay, the police gradually drove them in that direction, and so succeeded in separating the combatants. About nine o'clock a fresh force of policemen were sent up from Jarrow, and these, with the men regularly stationed there, managed to keep the place com-paratively quiet. After the vicinity of the club-room had been cleared, though the township wore an excited look, there were no more fights. Men and women stood in groups discussing the events of the day, and after "closing time" the streets began to empty. The main body of the policemen returned to Jarrow by the half-past eleven train, and all re-mained quiet during the remainder of the night. It was said that some of the combatants had revolvers in their possession, but if such was the case they kept them out of sight. But if these dangerous weapons were not in use, other weapons of a less dangerous character were, and there is little doubt had it not been for the arrangements of Superintendent Harri-son, and the pluck and general good behaviour of his men, there would have been a serious riot. As we have said before, Inspector Harrison and several other officers were struck with stones, they, by their activity being conspicious marks. The police officers who, under Superintendent Harrison, guarded the Orangmen to the station were Sergts. Hedley and Waugh, P.C.'s Surtees, McLean, Laycock, Maughan, Nicholson, Feasey, Cooney, and Wilkinson, the last three being in plain clothes. The force at Hebburn was under Inspector Harrison, and comprised Sergts. Elliott and Reed, P.C.'s Robson, Frazer, Walton, Gant, Boyes, and several others from Jarrow.

Above left: A return to crime in Jarrow and Hebburn. A riotous day with various objects thrown. *Jarrow Express*, 18 July 1879.

Above right: The disorder continued. Part two of the article dated 18 July 1879.

Would you launch into a shouty standoff if your singing voice were disrespected late at night? In October 1880, a young and mischievous man called Benjamin Hogg was summoned to court for drunkenness, brawling and had made an absolute nuisance of himself at Pearson Place. He denied the charge, though admitted he had been drunk, and yes, he had been noisy too, but he rebuffed the accusation he had fought another man. 'I was only quarrelling over a singing contest,' he had said. Unluckily for him, he was fined 5s and costs.

ONKTON VILLAGE. (500)

The Orange March had begun in Monkton. (Postcard sourced from Kevin Blair)

Jarrow was still the wild west of the North East. If it wasn't guns, the inhabitants used whatever came to hand. By August 1883, Annie Bowes fought with her husband in their home on High Street. She carried a fire poker while he wielded a coal rake. When PC Walker interfered with the couple's deadly skirmish, Annie attacked him with the poker and was bound over to keep the peace. Reversing the years, June 1864 would not be considered Catherine Gosson's month. In the neighbourhood of Jarrow Church, close to St Paul's, Eliza McCaffery would be summoned to police court for assaulting Catherine and was fined 2s 6d. Catherine Gosson, however, had lost her temper the same day and had thrown boiling water over Ellen Cassidy. With Cassidy's neck scalded, the incensed Gosson had pressed the scorching pan against another woman's nose. Despite complaining bitterly of the Jarrow women who constantly annoyed her, the rampage with the pain of boiling water earned Catherine a 5s fine.

CHAPTER 6

THEY NOW LIE IN THEIR COFFINS

Have you ever thought about the officers of the Durham Constabulary whose trusted boots once patrolled the streets of Jarrow? Men like George Hedley, Thomas Padden, and George Merrells. Three policemen, each stationed in Jarrow, their names well known and respected in the borough. Their stories lay forgotten, much like their graves, but this chapter will explore their contribution to the town they once called home.

Police Sergeant George Hedley had lived in Jarrow since November 1865. On Saturday 5 September 1874, George patrolled Albion Street when he heard word of violence on Grange Road. Anne Lyons and her husband James had entered Mr Wright's public house when cross words were exchanged at the bar with a group of men. They went outside to meet Anne's family. Her mother Bridget Devanney

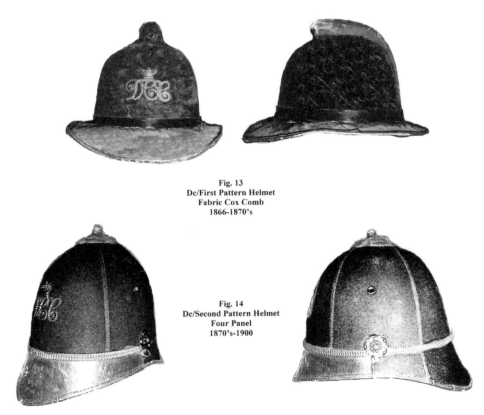

Fig. 13
Dc/First Pattern Helmet
Fabric Cox Comb
1866-1870's

Fig. 14
Dc/Second Pattern Helmet
Four Panel
1870's-1900

Two Victorian period Durham Constabulary police helmets. (Courtesy of Malcolm Smith)

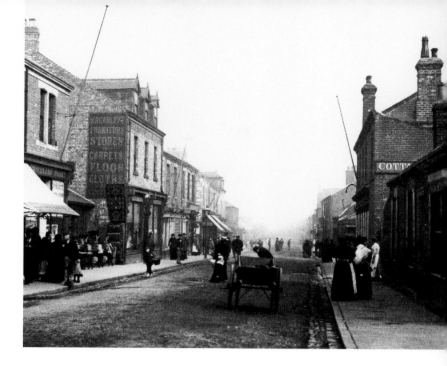

Grange Street, Jarrow. Date unknown. (Source: Kevin Blair)

and brother James soon arrived. There were a dozen men outside the pub and Patrick Kelly asked Lyons if he could fight nine of them.

'I will be a good man if I could fight one,' Lyons had replied.

Lyons was shoved by one of the men, but Mr Wright intervened and pulled Lyons inside. James Devanney attempted to enter the pub too, but Kelly struck him, knocked him on the ground and kicked him. Bridget helped her son up, but the men dragged him further down Grange Road as his mother and sister screamed. Roughed up by the group of drunks and troublemakers, James defended himself and was left with torn clothes and a bloodied face. His sister fought some of their attackers off with her umbrella as Patrick Kelly declared, 'Devanney, you'll die, you bastard!' He pulled a gun from his coat pocket and fired.

The bullet grazed James' forehead. 'You would not shoot me,' he said, startled.

'You bastard, you'll die now,' Kelly told him and fired again.

The bullet struck James in the face, and he fell to the ground, bleeding from the throat. His desperate mother rushed to protect him, and she caught hold of Patrick Kelly. Kelly retaliated and threw her into a muddy puddle of water beside her son and had fled by the time Police Superintendent Salter arrived at the scene. Salter believed James had died from his injuries, and when he spotted Sergeant Hedley, they both raced after Kelly.

Isabella Gilchrist, who had witnessed the violence, seized hold of Kelly as he pushed past her. He called her an 'old bugger' and threatened to shoot her. He shoved her violently and ran in the direction of Burns Street where he tossed the gun and continued to flee. A Mr Coulson secured the weapon, while John Fisher captured Kelly as he attempted to clamber over railings. Handed over to Sergeant Hedley, Kelly was escorted to High Street where a police cell awaited him.

CUTTING AND WOUNDING AT JARROW.—On Saturday night, a seaman named Alexander Edwards, residing at Jarrow with his brother-in-law, Richard Laidler, was taken into custody by Sergeant Hedley, of the county constabulary, on a charge of stabbing Laidler with intent to do him grievous bodily harm. The two were drinking together in the Hylton Castle public house, High Street, Jarrow, on Saturday night, and about nine o'clock Edwards, being considerably under the influence of drink, began to quarrel with his brother-in-law. After wrangling for a time they both went into the back yard, where a scuffle ensued, during which Laidler cried out that he was stabbed in the back. The two were immediately separated, and Sergeant Hedley was called in and took Edwards to the lock-up. The wounded man, who was bleeding profusely, was attended by Dr Thompson's assistant, who found an incised wound on his back, about half an inch in depth. The wound was evidently caused by a knife, and the blow must have been of considerable force, as two thick shirts were penetrated. Laidler was yesterday progressing favourably.

Above: Burns Street, Jarrow, 6 July 2021. Photographed by Ewen Windham in the rain.

Left: One of Hedley's police cases, *Jarrow Express*, Monday 18 November 1867.

James Devanney's injuries were serious. His arms and head were paralysed. Dr Bradley explained it was possible Devanney would regain use of his limbs. The second bullet had also struck a bystander named Lister in the leg, and Kelly was charged with intent to murder, and one of his friends, Daniel Dunning, threatened Bridget Devanney not to testify at the trial. She reported the threats and Dunning was cautioned and bound over to keep the peace at a cost of £10. In mid-September, and with no improvement of James' injuries, his brother Patrick saw one of Kelly's friends in the street. He punched Philip McDonald and knocked him down. He was fined 20s and costs after Superintendent Salter had witnessed the assault. Kelly, accused of being a 'Fenian head centre' was sentenced to twenty years' imprisonment for the shooting of James Devanney.

Sergeant Hedley, known as 'Father Hedley' to some, was a respected and well-liked member of the police force. In February 1887, he arrested Michael Feeney in North Shields after an altercation at Mr Duff's beerhouse in Ellison Street, Jarrow. Feeney and other platers' labourers at Palmers went on strike. As they sat in the bar, and after several drinks had been consumed, a fight broke out and blows were traded between Feeney and Patrick Madden. Feeney had left the pub and returned with a jagged rock. He struck Madden several times across the head and then fled. When he saw Madden in a bloodied state and walking home, he once again attacked the injured man with his fists and ran when he spotted a policeman approaching. Madden survived the dangerous assault and Michael Feeney was sentenced to twelve months' imprisonment.

Also involved in the investigation of the John Docherty murder, George Hedley died on 22 June 1883 at the age of fifty-two. Despite the heavy rain showers, his funeral procession was witnessed by hundreds of Jarrow inhabitants. Four police sergeants carried the black coffin to the waiting hearse outside the catholic chapel at the police station. Superintendent Joseph Scott and the other constables led the hearse on foot to Jarrow Cemetery. 'Never a very robust man, his health broke down a few weeks ago. He had an attack of heart disease,' the *Jarrow Express* had stated mournfully of Hedley's demise.

Another popular member of the Durham Constabulary was George Merrells, a native of Surrey. After twenty-six years' service, he retired in 1894. He was presented with a marble timepiece, a set of bronzes, a gold albert watch, a purse

Another one of Sgt Hedley's cases from the *Jarrow Express*, 24 January 1879.

—*Thomas Carr*, labourer, Newmarch-street, for being drunk in the same street on Saturday night last, was also fined 2s 6d and costs.—*Martin Logan*, holder-up, Curry-street, was charged with being drunk and disorderly in Grange-road on Saturday night. Sergeant Hedley said the man was very drunk and wild. Defendant's mother said her son got hurt in his head when working down the pit when a boy, and when he got drink it affected him. Fined 5s and costs, the Mayor remarking that the reason given by the mother should be a greater inducement for him to keep off drink.

Left: Sergeant George Hedley's headstone at Jarrow Cemetery.

Below left: Sergeant Merrells attacked in the line of duty, *Jarrow Express*, 22 June 1883.

Below right: Sergeant Merrells to the rescue. *Jarrow Express*, 24 April 1885.

A SATURDAY NIGHT RIOT.

At the Borough Police Court, on Monday, before Ald. W. H. Dickinson and other magistrates, *William Brown* and *Patrick Devlin* were charged with being drunk and disorderly on Saturday night. The latter, who appeared to be a sea-faring man by his dress, was further charged with assaulting Sergt. Merrells and P. C. Sagar; and *Bridget Duffy, Catherine Chambers, Mary Jane Glass*, and *Mary Ann Cargie*, young women, were also charged with assaulting Sergt. Merrells at the same time. It appeared that about 7·30 on Saturday night, the two male defendants were creating a disturbance in George-street. They were very drunk, and were ordered away. Refusing to go home, they were taken into custody by the officers. Devlin then became very violent, and attacked the officers with fists, feet, and teeth. A large crowd, computed at hundreds of people, soon gathered, and the officers were stoned. The female defendants were among the crowd, and resisted and assaulted Sergt. Merrells in the execution of his duty, one of them striking him with a stone. Devlin left his teeth marks on both officers. The male defendants pleaded guilty to being drunk, but denied being disorderly, and Devlin denied striking the sergeant. The female defendants, when charged, readily pleaded guilty, but afterwards denied that they had in any way interfered with the police. The male defendants were fined 5s and costs each for drunkenness, and Devlin and the female defendants were fined 10s and costs each for assaulting the officers. The women made a great noise when removed, some of them shouting out "Good-bye; I'll take a month," &c.

ALLEGED SAVAGE ASSAULT ON A JARROW POLICEMAN.

There is in custody at the Jarrow police-station a labourer named John Lavory (who is powerfully built), on three charges, viz: with having been drunk and disorderly, assaulting Sergt. Merrells, and wounding P.C. Gilroy. It appears that shortly after midnight on Monday, P.C. Gilroy saw the prisoner lying in a state of drunkenness on the pavement in High-street. He told him to go home, and before he could well offer any resistance the prisoner rose to his feet and sprang at him, striking him several blows. The officer drew his truncheon when the prisoner closed with him. Prisoner got possession of it and using it violently struck the officer a number of blows on the head. The latter blew his whistle, and the prisoner ran off with the baton, while he lay in an exhausted condition.—Sergt. Merrells, when in Albert-road, heard the whistle, and proceeded to the corner of High-street, and afterwards to an adjoining back lane, where he found the prisoner. When approaching the prisoner brandished the truncheon. He also closed with the prisoner, and succeeded, after a struggle, in possessing the weapon, and apprehending the prisoner with the assistance of P.C. Featherstone, who had been attracted to the scene by the noise. The prisoner, who assaulted the sergeant in the back-lane, was safely lodged in the police cells. In the case of the wounded constable, medical assistance was obtained as soon as possible, and the scalp wounds, of which there are no fewer than nine, were dressed.—Yesterday the prisoner was brought before Ald. Dickinson and George Johnson, Esq.—Inspector Snowdon said he had seen P.C. Gilroy, the wounded constable, that morning. He was unable to leave his bed his wounds being of so serious a nature.—The Bench remarked that the case appeared to be a serious one, and complied with the request of the Inspector for a remand for seven days.

that contained twenty guineas, and his beloved wife was gifted a silver cruet set, a diamond ring, and a matching diamond brooch. Before his retirement, he worked tirelessly in Jarrow.

On Tuesday 14 July 1885, there were constant scuffles between newspaper boys on Palmer Street. Ten-year-old Samuel Carlisle had been struck by fifteen-year-old James Dalton, causing the young boy to fall and strike his head on the pavement. Dalton had warned Carlisle not to walk down the same street as him. The crying Samuel was later seen beside the railway station, kneeling against a wall. When David Glass asked him what the matter was, Samuel had answered, 'Dalton has been hammering me.' He complained of pain in his head, was weak and could not walk. Samuel's sister arrived and with the help of two other boys they carried the vomiting Samuel to the newspaper office on Ellison Street. When they reached the office, Dalton opened the door.

'What did you bring him down here for?' Dalton demanded to know.

'Do you think I was going to see him die up there? Look what you have done, Dalton,' Glass said.

'Shut your mouth,' Dalton snapped and blamed Glass for the young boy's injuries.

While they argued, Samuel collapsed and his enraged sister warned Dalton, 'I'll bet you a shilling you pay for this.'

'I'll do the same to you in a minute,' Dalton told her.

Worried her son had not returned home, Mary Ann Carlisle went to the newspaper office where she found him in a collapsed and tearful state. When she discovered Dalton had harmed him, she was furious. 'You villain, what have you done to my son?'

Ellison Street, Jarrow. Date unknown. (Courtesy of Kevin Blair)

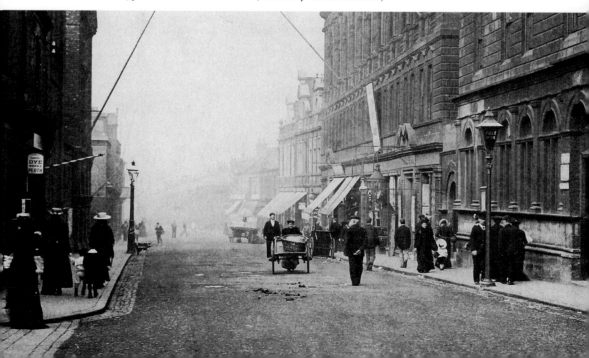

Dalton blamed Samuel, said the younger boy had thrown stones, then he threatened to do the same to Mrs Carlisle. 'Oh, you scoundrel, what have you done to Sammy to make him pick the stone up? He's only a child,' she replied.

She took her son and rested in Davis' Refreshment rooms on Ellison Street. Bathing his head, his condition seemed to worsen. It was now 7 p.m. and Sergeant Merrells arrived and discussed the violent incident between the newspaper boys with Samuel's mother. His own son, John, was the same age as the ailing boy.

'He seemed to be very ill,' Merrells later said. 'From information I got I went to Dalton who was in the newspaper office. I asked him what he had been kicking Carlisle for? He replied, "He hit me, and I hit him, and knocked him down; but I did not kick him." The deceased Samuel Carlisle is around 4 feet 3 inches high as he now lies in his coffin. He is much less than the other lad.'

At 11p.m. Dr Bradley arrived at the Carlisle home, but tragically Samuel had died. His body was moved to the mortuary behind the Corporation Chambers, and Bradley performed an autopsy while crowds gathered outside. Samuel had a fractured skull, a concussed brain and several abrasions on his legs and arms. Despite Dalton stating, 'The blow I struck would not kill a bug,' he was charged with murder at the inquest and fainted several times in the witness box until his mother sat with him. The jury at the inquest reduced the charge to manslaughter and Dalton stood trial at Durham. His defence lawyer suggested Samuel had died from misadventure and the jury found James Dalton not guilty.

THE LATE ICE ACCIDENT.

Sir,—Will you kindly allow me space in your columns to tender my sincere thanks to my many friends in the town and district for their sympathy with me and my family in our affliction by the drowning of my son, John Edward Merrells, on the 27th ult.
 For their great kindness I also wish to especially thank Mr A. Moodie, my son's music master, and the Hebburn Temperance Band and their leader ; Mr T. Wilson's choir, from St. John's Wesleyan Chapel, at which school my deceased son attended.—I am, sir, yours truly, GEO. MERRELLS.
 Jan. 5th, 1888.

Above: George Merrells' heartfelt letter in grief, *Jarrow Express*.

Left: Jane, the wife of Sgt George Merrells. Despite extensive research and tracing countless descendants of George and Jane I have been unable to uncover a photo of the police sergeant. (Photo courtesy of Suzanne Pagès-Slassor.)

DEATHS.

JARROW.—At 182, Albert-road, on the 30th inst., aged 49 years, David Kay, builder, the beloved husband of Barbara Kay. Interment at Jarrow Cemetery on Sunday at 2.30. Friends please accept this the only intimation.

On the 19th inst., at 21, Shakespeare-street, James Morris, aged 42 years.

On the 23rd inst., at 29, Union-street, Elizabeth Helen Kerr, aged 23 years.

On the 24th inst., at 15, Wear-street, Elizabeth Batey, aged 56 years.

On the 25th inst., at 24, Oak-street, Catherine Donaghay, aged 28 years.

On the 26th inst., at 26, Holly-street, Mary Ann McPhee Morris, aged 7 years.

On the 27th inst., at the Brickfield Pond, High-street, James Gordon, aged 10 years.

On the 27th inst., at the Brickfield Pond, High-street, John Edward Merrells, aged 10 years.

HEBBURN.—On the 25th inst., at 35, James-street, John McHugh, aged 57 years.

On the 28th inst., at 27, Argyle-street, Mary Stephenson, aged 7 years.

On the 28th inst., at 13, William-street, Walter Burke, aged 43 years.

Death notices of John Merrells and James Gordon, *Jarrow Express*, 30 December 1887. Eventually the Merrells family left Jarrow and George became the landlord of a pub. He died in 1914 and is buried at Haughton Le Skerne, County Durham.

George Merrells was a family man and lost his own son on Tuesday 27 December 1887. John Merrells, aged twelve, had spent the morning playing the fiddle. When his friends knocked on the door, he was excited to go outside and play. In the bitterly cold air, on the late-December morning, the boys skidded, skated, and slid across the frozen Brickfield Pond at High Street. Suddenly, the ice shattered, and they fell into the freezing water. An elderly woman had witnessed the accident and hurried home to fetch a clothesline. Another witness, an old sea captain named Farquar searched the pond for the missing boys. When news spread of the accident, the police arrived at the scene and were closely followed by John's distraught parents. While the police frantically held onto the screaming Mrs Merrells who had attempted to rush into the water, her husband, George, leapt into the pond in search of his son and the other missing boy, James Gordon. The enormous pond was 8 to 10 feet deep, and no sign of the boys could be found. The distressed Merrell family were escorted home by George's colleagues, and a police constable visited the Howdon Yard of the Tyne Commissioners for equipment. Hours later, the police had used a rough plank of wood to reach the middle of the pond and hundreds of spectators watched the boys' bodies brought to the surface of the water by grapnel hooks. By 1894, Sergeant George Merrells had retired and left Jarrow. He worked as a pub landlord, died in 1914 and is buried at Haughton Le Skerne, County Durham.

Thomas Padden was born in Liverpool in 1856. Raised in a mining community, his family moved to County Durham in the early-1860s. He had begun his working life as a colliery winding engineman and joined the 2nd Durham Artillery Volunteers, whose headquarters were at Seaham Harbour. In 1876, he retired from the military

and joined the Durham Constabulary. Now a police constable, he married Bridget Scully in 1880 at Thornley, Durham. By 1892, Thomas had been stationed at Barnard Castle, West Hartlepool, Ryhope, Silkworth and Seaham Harbour. In 1895, Thomas Padden, now a sergeant, arrived in Jarrow. A father of seven, he arrested criminals daily before he returned to his family home on Stothard Street.

The cases he worked on ranged from the absurd to the dangerous and the tragic, and in January 1897, Thomas detained a drunk and disorderly William Woods on Staple Road. When he appeared in the police court, Woods had said, 'I plead guilty

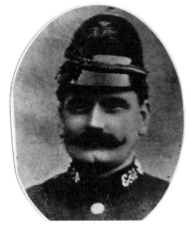

Left: Thomas Padden. (Photo courtesy of the Padden family)

Below: Stothard Street, Jarrow, 6 July 2021. (Photo snapped by Ewen Windham)

to being drunk but not the assault charge.' When arrested, Woods had been further accused of assaulting PC George in the police station while escorted to the cells. As soon as George had turned to close the cell door, he said Woods had struck him across the jaw, knocked him to the ground and kicked him. George claimed he had shouted for help and PC Parkinson and Sergeant Padden had run to his assistance.

'You should reverse the case, and instead of charging me with assaulting him, charge him with assaulting me. I am black and blue all over my body from their bad usage. I hadn't a mark on me till I was brought here on Saturday night,' Woods furiously told the magistrates.

PC Parkinson explained he had pulled Woods off PC George but in the struggle, they had fallen, and Woods had hit his head on the wash basin in the passage. 'I never touched him but was myself kicked all along the passage till the prisoners in the other cells cried "shame!",' Woods argued.

James Philips, held on a charge of vagrancy, stood in the witness box, and stated how he had seen Woods kicked repeatedly by an officer. He said Woods had been dragged out of his cell and kicked a second time.

The chairman was suspicious. 'It's rather strange that you managed to see the defendant kicked and nothing else that happened.'

'Oh, well, I didn't pay any attention after that,' Philips responded.

After Superintendent Fleming had announced it was William Woods' thirty-eighth appearance in court, the defendant was fined 10s for drunk and disorderly behaviour and informed he had already been well punished for attacking the police officer.

The following month, Padden dealt with two cases of drunkenness. He arrested Elizabeth McInany for being 'mad drunk' in Albion Street after she had caused a

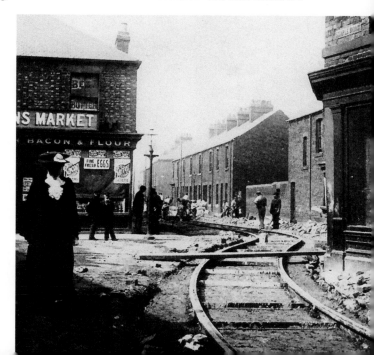

Laying the tramlines on Staple Road to Commercial Road in 1906. (Source: Kevin Blair)

great disturbance. Mrs Lynch, who kept a boarding house, complained Elizabeth had broken a window, threatened to smash everything in the house and struck her across the face. On the same evening, Padden arrested Stephen Newton after he had witnessed him leave the Co-operative Store, staggering with drunkenness and knocking people off the pavement. Accused of begging inside the shop, using colourful language and threatening to steal, the enraged Newton complained bitterly of losing 18s. The drunken man later discovered the money in the bottom seam of his right trouser leg. Elizabeth was fined 2s 6d, and Newton received a fine of 10s and costs.

Drunkenness was not the only matter Padden dealt with. On the night of 9 July 1898, Sergeant Rutter had walked along Walter Street when he noticed an unusual glow on the ground floor of Mr Turner's hatter shop. He found the door unlocked and discovered the counter on fire. Sergeant Padden soon arrived on scene, and with the help of other officers and several neighbours, they carried buckets of water to the shop and put the blaze out. In the commotion, the Mills family, who lived above the shop, helped tackle the fire but due to the toxicity of the smoke mixed with excitement, Mrs Mills fainted and had to be carried outside by PC Pringle.

THE MOTOR CAR AT JARROW.

CHARGE OF OBSTRUCTION.

At the Jarrow Police Court, on Monday, David Martyn, of the firm of David Martyn & Co., engineers, Hebburn, inventor and builder of a steam motor omnibus, was charged with causing an obstruction in Ormonde-street, by leaving a motor car for an unreasonable time.

Sergeant Padden said that on the 26th ult. he saw the defendant's car standing outside the County Hotel, a hose being laid out of one of the windows of the hotel to the car. The car stood from 5·25 to 5·45. There was a very large crowd of people standing across the road. After that he went round the town, charging people a penny each for a ride. He afterwards came back to the County Hotel, and witness sent an officer to warn him.

Defendant denied the charge, and said he would not be there more than a quarter of an hour. He did not cause an obstruction directly, but he did cause one indirectly. The car was a novelty, and he could not help the people gathering. The thing was to get the people to shift out of the way when he wanted to start.

P.C. Gould corroborated the sergeant's evidence.

Sergeant Padden said the pipe was 7 feet from the pavement, and anybody passing along could go under it.

The Chairman said that there was no doubt that the car was a novelty, but defendant must not cause any obstruction with it. He would be dismissed

Defendant said he would do his best not to offend.

Motor car disruption at the County Hotel on the corner of Walter Street and Ormonde Street. *Jarrow Express*, 7 October 1898.

Still in July 1898, a more curious case Sergeant Padden investigated was an alleged breach of the lodging house bye-laws. Padden and Inspector Hildreth had entered William Botto's lodging house on Stanley Street. They walked into one of the bedrooms and found a man and woman in bed. The couple swore they were husband and wife, but Inspector Hildreth knew otherwise. He had already spoken to the man's wife and fetched her from a neighbouring lodging house. Hildreth brought her into the room and pointed to the man in the bed. 'Is that your husband?' he asked her. The woman confirmed the lying, cheating scoundrel was indeed her husband.

Padden's brush with the riotous Jarrow crowds and the Kensit Preachers, 28 November 1904, *Jarrow Express*. The Preachers were intent on ending ritualism in religion. Their leader had died after a chisel was thrown at him at a 1902 protest.

Kensit Preachers at Jarrow.

DISGRACEFUL SCENES.

According to posters announcing the fact on Friday evening three young men arrived in Jarrow in connection with the above. They went to the top of Union-street and addressed a large attendance. On Saturday evening, however, a change had come over those gathered ; for it was very soon apparent that they intended to upset the meeting. There was a great deal of booing and shouting. The preachers did not heed this, and the crowd grew more hostile. The speakers used a box to stand upon, and this was kicked from under one of the speakers, the contemptible action being hailed with cheers and shouts of approval. There was a strong force of police present under Inspector Padden, and when the box was kicked away the policemen made their way into the crowd to protect the preachers, one of whom complained that he had received a blow in the face, and other people complained of having been struck. The inspector warned those present against any disorderly conduct. On the preacher attempting to resume the disorderly conduct re-commenced, the box being again kicked from under the preacher. A signal was given and the crowd closed in from behind, and the police and preachers were pushed into Ormonde-street. Arrived in the main thoroughfare the police cleared a space and the preachers got away, going in the direction of Ellison-street, followed by a hooting and jeering mob. The young men took refuge in the Mechanics' Institute, and subsequently went to South Shields by train.

On Sunday afternoon the preachers again visited the town, when between 2,000 and 3,000 people gathered. Again there was a number present who were bent upon creating a disturbance. During the service Mr John Devlin, who owns the ground at the top of Union-street, requested them to get off the land, and as this was not complied with the scenes of disorder re-commenced. Cries of "Get off the man's land" were heard on all sides. At the close of the proceedings the crowd showed some unmistakable signs of hostility, and the police went in to protect the preachers down to the boatlanding. The crowd followed shouting and hooting. There was also stone-throwing. The members of the Salvation Army and several civilians also assisted to escort them to the boatlanding. A mob gathered again at night ; but the young men had informed the police that they did not intend to come, and so the crowd were disppointed.

The woman in the bed now admitted the man was not her husband. She had met him in a public house, he had bought her a glass of beer and brought her to the lodging house. On hearing this, an appalled Botto promised to evict them. The case was referred to Jarrow Police Court but was thrown out by the magistrates. It's doubtful the man's wife was as forgiving!

In the continued exploration of July 1898, Sergeant Padden patrolled the Whitburn area where the Durham Artillery were camped for two weeks. On the evening of Friday 29th, two militia men, Peter McDade, and Francis Lynch, were drinking in a local public house when they quarrelled over their singing abilities. They walked into the street and drew the attention of Padden. He followed them and sensed trouble in the air, but the men parted ways and Padden returned to Jarrow. Later that evening, McDade and Lynch met on the sandy beach at Whitburn each with a companion at their side. Several local miners watched the fight. The scuffle lasted for some time until McDade was knocked unconscious by Lynch. The men left McDade on the beach. At 4 a.m., his friends carried him to the militia camp in a serious condition.

The men left McDade on the beach. At 4 a.m., his friends carried him back to the militia camp in a serious condition. Surgeon-Lieutenant Rowland attended the stricken man, but his condition worsened, and he died at 9 a.m. Lynch was arrested by Colonel Ditmas and escorted to a Jarrow police cell by Sergeant Padden. At the inquest at the Ship Inn at Whitburn, McDade, who had been more violent during the fight, had died from a blood clot on the brain. The death was recorded as 'misadventure' and Lynch was released from police custody.

In 1901, Thomas Padden was promoted to the rank of police inspector. Regarded as having discharged his duties with great tact and judgement, he started his new role on 1 July. By March 1905, Padden was involved in the strange case of seventeen-year-old John William Davison and the burglary on Holly Street. John's stepfather, Edward Hill, had visited the police station to report a robbery and shooting. He told Inspector Padden that Davison had been shot by the intruder. With Superintendent Fleming and Sergeant Binns, Padden rushed to the address on Holly Street. Davison, cradling his injured arm, told the police he had disturbed the burglar and chased him downstairs. The man, who had been armed, shot at him twice and then escaped from the home. Struck once by a bullet that lodged in his arm, Davison was not a believable witness.

The police were suspicious of the scene. Had it been the work of an amateur? In a search of Davison's bedroom, the missing money was found hidden in the chimney breast, and a gun and several cartridges were discovered in his coat pocket. He was arrested for burglary much to his stepfather's shock.

The chairman of Jarrow police court asked, 'Have you anything to say why you should not be remanded?'

'I have nothing to say,' Davison replied.

Edward Hill pleaded for leniency on behalf of his stepson and informed the magistrates he did not wish to press the charge. The Bench, however, were determined

to punish John William Davison and sentenced him to four weeks imprisonment at Durham with hard labour. The police were commended for their investigation.

In February 1906, five-year-old John Lightfoot, with a tin fish in his hands, played beside the swollen River Don with his friends. At five-thirty that evening, Lightfoot was left alone with his tin fish at the water's edge. John Fraser Grey, on Ballast Hill, watched the boy drop the toy into the river and attempt to retrieve it. To his horror, he saw Lightfoot fall into fast flowing current. Grey ran across the field where he met two boys and a butcher. They hurried to the riverbank, tied a rope around the butcher and helped him into the water. None of them could swim but they desperately tried to save the young boy's life.

As John Lightfoot Snr sat down to dinner at No. 195 High Street, a messenger knocked on the door and told him his son had fallen into the Don. The terrified father sprinted over a mile to the scene of the accident. By the time he arrived, the butcher was in great difficulty and his son's body was about to disappear down the river. John threw himself into the water and swam towards his son.

Inspector Padden and Sergeant Binns waited on the riverbank as John pulled the lifeless body from the river. Padden and Binns spent thirty minutes performing CPR on the young boy but, unfortunately, he could not be saved.

On the day of the inquest, the coroner discussed how it had been an incredibly high tide that day and the fact nobody could swim had hampered efforts at saving John's life. He commended the police's attempts at CPR and thanked the boys for saving the butcher's life when he had gotten into difficulty in the water.

On 12 August 1912, Inspector Padden retired from the Durham Constabulary after serving thirty-five years. Alderman Reavely announced the retirement at the close of police court that evening and expressed his hope that his dear friend would have many enjoyable years ahead of him. However, Padden soon returned to duty in the Special Police Reserve because his pension had been too paltry to live on. When he finally retired, he was seventy-one, and considered one of the oldest serving police officers in the country. Described as a man who once handed striking miners police boots for their tired feet, Inspector Padden died on 25 April 1930. He is buried in Jarrow Cemetery.

Thomas and Bridget Paddens' grave at Jarrow Cemetery. (Source: Natasha Windham)

CHAPTER 7

I'LL DO FOR YOU

It was early November 1898. A small boy, Thomas Horne, had been charged with sleeping on the streets after he was found on the doorstep of his mother's home, half-frozen and hungry. Police Inspector Hildreth climbed through the back window of the house and found it unoccupied and untidy. With the boy's mother in the frequent habit of vanishing at night and leaving her son to fend for himself, the case swept her into a courtroom where she promised to look after her son, and they were both dismissed. I'm certain, as you read this, you are wondering why a child would be charged with vagrancy after he was discovered on his own doorstep, seemingly abandoned, tired and frightened on a cold winter's night. The simplest answer is Victorian Britain and even Jarrow frequently collapsed

The back of Ferry Street in the present day, thanks to Ewen Windham.

into inconceivable cruelty, and often, people turned a blind eye even when help was needed.

By 19 November, cruelty would once again darken the door of a Jarrow home. On Back Ferry Street, at No. 26, lived seventy-four-year-old Ann Hoy with her two sons, Joseph and the youngest John. Known by his middle name William or 'Billy' for short, her son, John, was twenty-four. Ann was widowed and sometimes craved whisky. While the Hoys lived in the downstairs rooms, Charles and Mary Ann Algar lived upstairs. That afternoon, Charles had been caught short and headed outside to use the WC in the shared yard. As he settled on the toilet, he heard a commotion from the Hoys' kitchen. A crash, pleading words and a chilling threat spilled from the window.

'Oh Billy, don't, you're killing me!' Ann wept.

Further threats and expletives could be heard from William. Ann screamed and he said, 'Go on, shriek away, have anybody in the house if you dare.'

Charles heard another crash and further commotion as William shouted, 'I'll do for you!'

Leaving the toilet, Charles could see Ann's silhouette at the kitchen window. It looked like she was falling. When he heard William's footsteps coming towards the door, Charles hid inside the WC. He watched William look around the yard, gaze upstairs and then return to the kitchen.

His wife, Mary Ann, also heard the disturbance. The noise had continued for half an hour, and she thought little of it because it was a regular occurrence. At 10.30 that night, she was outside in the yard when Ann appeared at the kitchen door and called out to her. When Mary Ann saw her neighbour, she was shocked. Anne's eyes were blackened, her nose was bleeding, and her clothes were torn and stained with blood. Mary Ann asked who had done it, and Ann answered, 'Billy Hoy'. An hour later, another fight between Ann and William was overheard by the neighbours upstairs. Charles thought it sounded like blows that struck Ann repeatedly, and still, they refused to interfere.

Joseph Hoy had returned home frequently that day. At 11.30 that night, his mother was sat on a sofa in the kitchen, head down and face covered with her hands. She would not look at him, even when he asked where his pawn ticket was. She told him to check the washhouse and he left. It was the last time he would see his mother alive. Unhappy she was drinking alcohol again, he chose to sleep in lodgings on High Street overnight.

Patrick Mulley had also seen the injured Ann on Saturday afternoon. She was bleeding from the nose and her black skirt was bloodstained. He told her he would fetch a policeman, but unable to find one close by, he told a neighbour about her injuries instead. Ann then walked to her neighbour Annie Carl's house and asked to borrow 6*d*. Bleeding from the face, Ann complained her sons refused to give her money. Annie politely declined Ann's request, and later saw William on Ormonde Street.

'Hello Billy, is that you?' Annie said.

'Yes,' William answered.

'Come on home like a good lad; you have been using your mother badly tonight,' she told him, but her husband Thomas had lectured her for interfering and said she had nothing to do with it.

Joseph, meanwhile, had eaten dinner at the Cocoa Rooms, and the next day, he returned home at 8.30 in the evening to check on his mother. She was lying on the kitchen floor with her face bruised and blood flowing from her nose. He crouched beside her and lifted her hand. It was still slightly warm, and he let it drop to the floor. She was unresponsive and he rushed from the house to call for their neighbour, Mary Ann.

Mary Ann had witnessed William leave the home that evening, thirty minutes before Joseph had returned. On reaching the gate, William had nodded and said to Mary Ann, 'It's a fine night.' Now she stood in the kitchen with a broken chair and a murdered Ann Hoy. Dr Norman pronounced Ann dead at the scene, and in mourning, Joseph walked to his sister's home to break the news of their mother's death.

Mary Ash, Ann's daughter, had been estranged from her family. She had last seen her mother six months previously. After learning of the tragedy, Mary and her neighbour visited the scene of the crime. Finding a bundle of her mother's clothing in the front room, she carried them home. She later explained to the coroner at the inquest that when she realised the clothes were covered in blood, she took them to Mrs Walters, who she said was her washerwoman. The police found the bloodied evidence in Mrs Walter's washhouse, but she denied she was employed as a washerwoman and explained she was simply storing the bundle for Mary Ash. Mary had spoken to William the day of their mother's death. She refuted she had questioned him and admitted she could no longer enter her mother's home because the police had the key in their possession.

During the post-mortem, Ann's horrendous injuries were catalogued by Drs Norman and McMurty. She had a fractured nose, bruised eyes, face, nose and lips, the cartilage of her left ear had burst, there was bruising to her hands and arms, and haemorrhages to the back of her scalp, left temple and left ear. Her son, William, was arrested on the 21st at 1 a.m. When charged with Ann's murder, he said, 'It was a bad job; we've had a lot of trouble with her. She was always drunk.'

At the inquest, the coroner suggested there was little doubt that Ann had died from violence despite the unwitnessed assaults. The jury retired for less than thirty seconds and announced on their return, 'We find deceased met her death at the hands of her son William, deliberately, or in other words, wilful murder.'

While Ann was buried at Jarrow Cemetery on 25 November, William was remanded in custody and sent to Durham Gaol. At his trial he pleaded guilty to manslaughter, and the judge, Justice Lawrence, consulted with the foreman of the jury. Due to the evidence given by Dr McMurty when he had pondered aloud, 'The fracture of the nose might have been caused by a blow or a fall against

something blunt and rounded, and the other bruises might have been caused by blows or falls against any blunt, rounded projection'. The foreman decided the evidence was inconsistent with violence and William Hoy was discharged from court. Now a free man, William returned to his hometown. The town of Jarrow was outraged, the coroner was in uproar, and the inhabitants of the town beside the River Tyne continued to gossip about William Hoy's brush with the hangman's noose.

Ann Hoy was buried at Jarrow Cemetery. (Source: Natasha Windham)

CHAPTER 8

I KNOW NOTHING ABOUT IT

This is the story of Thomas Dixon, David Glass, Alexander McLaren and Joseph Andison. This is the story of how their fates were entwined by a trigger finger, a revolver and an unstable mind. This is the story of a murderous sprint across Jarrow in the dead of night with a six-chambered gun and a pocket full of cartridges. This is the story of murder, mayhem, gun crime and a thorough manhunt that spun around a painful instability that had begun on Walter Street and ended on Cemetery Road. This is the story of a deadly rampage by Dixon, and it started on Kings Street, South Shields, on Saturday 18 January 1896, at 7.30 that evening.

A Palmers steelworker Thomas Dixon, aged twenty-one, had entered a store on Kings Street. He spoke to the manager and pointed to the window display. He spoke to the manager and pointed to the window display. He asked about a pistol and wanted to view it. After inquiring the price, he paid 5s to purchase it. Think about that for a moment: *Five* shillings for a dangerous weapon. After buying a

An atmospheric snapshot of Kings Street, South Shields, date unknown. (Used with Kevin Blair's permission)

box of cartridges for 1s 6d on the same street, Dixon returned to Jarrow. That evening, he entered the County Hotel with friends Alexander McLaren and John Baird. They drank together and Dixon showed Baird the gun and asked what he thought of it. Baird suggested Dixon put the weapon away and they continued to drink. They left the bar and walked to the Lord Nelson Inn on Walter Street. After the manager suggested they were drunk and refused to serve them, they stepped outside onto Walter Street and Baird bid them goodnight. Dixon and McClaren continued to talk until volatile words were overheard.

David Glass, who would later claim to be surrounded by strong women, witnessed Dixon produce the pistol and hold it against McClaren's chest. 'I've a good mind to shoot you,' Dixon said. Thirty seconds later, Dixon pulled the trigger and McLaren collapsed as the words, 'Oh! Oh!' spilled from his dying lips.

At the coroner's inquest into the death of McLaren, Glass said, 'Although I saw the pistol presented and held at McClaren's breast about half a minute, I was unable to interfere to prevent him being shot because I was on the opposite side of Walter Street and was held by three young women.'

Walter Street, Jarrow, where the drunken fun ended, and the violence began. (Image courtesy of Ian Turnball)

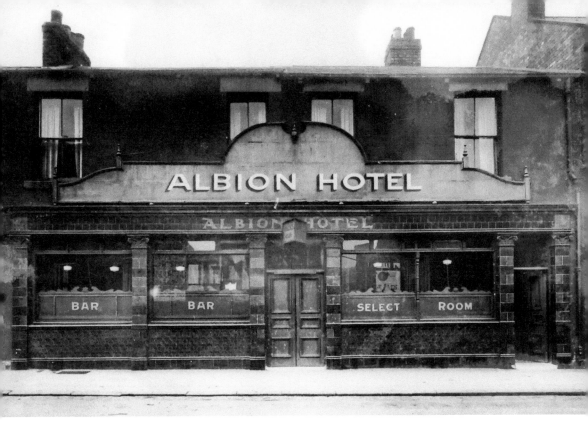

THE JARROW MURDER

Thomas Dixon, who was sentenced to death at Durham Assizes on Monday for the murder of Alexander McLaren, at Jarrow, now lies in Durham gaol awaiting execution. He is only 21 years of age, and his calling

THOMAS DIXON.

was that of a labourer. Three Sundays generally elapse between the sentence and the carrying it into effect, so that unless reprieved, Dixon will probably be executed in the week beginning Monday, March 23.

Above: One of the other public houses on Walter Street, the Albion Hotel, Jarrow. Date unknown. (From the personal collection of Kevin Blair)

Left: A sketch of Thomas Dixon, 5 March 1896, *The Newcastle Evening Chronicle*.

'However strong these three young women may have been and however much they might have stopped you, when did you break away?' the coroner questioned.

'I broke away from them directly when the shot was fired and I followed the man into the bar, but when I got inside, he was gone,' Glass replied.

Councillor Reavley said, 'Does the witness wish us to believe that he saw a man standing holding a revolver to a man for half a minute, and that he did not know the man again?'

'This is his evidence, whether you believe it is another matter,' the coroner responded, and then asked Glass, 'Do you pretend to tell us that you did not know the man?'

Glass shook his head and had changed his first statement to the police. At the inquest, he now pretended he did not recognise the gunman. 'No, sir.'

The coroner sighed. 'That is a matter between you and your conscience. What you have stated I have taken down and you will have to answer it.'

The foreman of the jury interjected with his own question. 'Were you perfectly sober?'

'Yes, I was. I have known Dixon over two years,' Glass told him.

The foreman remained sceptical. 'Then you wish us, a jury of thirteen Englishmen, to believe that you stood there, with the light full on, and saw a man holding a pistol to another man, and that you could not identify him.'

'No, sir. The young women were holding me,' Glass answered.

The coroner grew tired of David Glass' excuses. 'Never mind the young women, you are too fond of blaming the young women.'

Glass remained unwavering in his evidence. 'I have known him two years but could not distinguish him that night.'

The foreman interrupted with another question. 'It is no use bulking the fact, sir. What made the young women hold you?'

The coroner had heard enough. 'You can place what value you like upon it. He could have got away from them unless indeed, the Jarrow women are very strong. If a man tells one story today and another before another court, he must bear the consequences.'

In a state of collapse, thirty-two-year-old Alexander McLaren, was carried to Penman's Chemist shop and then to Palmers Memorial Hospital. Thomas Dixon had rushed inside the Lord Nelson Inn and fled through the side door. The gun he had once concealed in his trouser pocket was now firmly held in his right hand and he sprinted towards Monkton Road. Joseph Andison, aged twenty-two, was walking home arm in arm with his sweetheart Margaret Collins. Suddenly, Thomas Dixon appeared and silently raised the gun and fired at Andison. Shot in the face, Andison stumbled and fell, and would later die in agony after the bullet travelled to his neck and severed his spinal cord. Dixon continued to run until he reached Springfield Road. He came across three men who belonged to Boldon Colliery. Robert Smith, John Thompson, and John Riley had spent the

Above: At the far left was Thomas' murderous route down Springwell Road. (Thanks to Ian's drone once again)

Left: Springwell Road in 1910. (Source: Natasha Windham)

night in Jarrow and were walking home when Dixon approached them. He fired at Thompson, but the bullet missed him and struck the unsuspecting Smith in the shoulder.

Dixon sprinted further along Springfield Road where he spotted George Brewis strolling in the direction of the paper mill cottages. He aimed the gun at Brewis and shot him in the face. Dixon doubled back and remained on Springfield Road where he met two women. Sarah Jane Lowther and Rebecca Alexander were returning home when they encountered Dixon. Wordlessly, he once again raised the gun, pointed it towards Lowther and pulled the trigger. The bullet whizzed past her head, and she screamed.

Mrs Alexander told him sharply, 'Don't fire that thing anymore 'til I get past!'

Dixon remained motionless and the women continued their walk until they stopped to help the injured Robert Smith. Heading in the direction of the cemetery, Dixon sprinted up the street and spotted George Sloan sat on a bench close to the cemetery gates. Sloan was in deep conversation with a woman he was courting when Dixon approached them. Still eerily silent, Dixon aimed the gun at Sloan and pulled the trigger twice. Nothing happened. Sloan leapt to his feet and attacked Dixon. He wrestled the gun from the murderous man's hands and

Cemetery Road in summer 2020. (Source: Natasha Windham)

Cemetery Road from the sky. (Source: Natasha Windham)

knocked him to the ground. Dixon fell on Cemetery Road, opposite the gates, and lost his cap in the struggle. He managed to find his feet again and fled towards the fields that surrounded the cemetery.

It was now 10.30 at night and news of further shots fired had reached the police. Superintendent Fleming already had men stationed at the railway station and boat and ferry landings, but when he heard of the violence close to the cemetery, he sent his unarmed officers to that location. On the road that Springwell Road meets Cemetery Road, PC Blackett stood, while Sergeant Thompson and PC Keen walked in one direction, and Sergeant Newlands and PC Walker walked in another. After a while, and in the quiet of the night, PC Blackett, still stood at the junction, heard rustling noises in the direction of the fields behind him. He watched a man fitting Dixon's description spring over a hedge and hide behind a bollard. Blackett had little idea whether Dixon remained armed, but he was determined to make an arrest. When he approached Dixon, the latter held out his arm as if he still held a gun. Blackett used his whistle to signal for help and with the assistance of his colleagues they captured Thomas Dixon on Cemetery Road. Immediately escorted to the police station on High Street, Dixon attempted to escape on Springfield Road and almost tripped PC Blackett. The latter retaliated by throwing Dixon to

The entrance to Jarrow Cemetery from above.

the ground and handcuffing him. Dixon threatened the police and was soon locked in a cell. He later denied any knowledge of his shooting spree and admitted his memories had only returned when he entered the police cell.

Charged with wilful murder at the inquests, Thomas Dixon was remanded in custody and sent to Durham prison to await his trial. On Monday 2 March, the trial started with a double murder charge and Dixon pleaded not guilty. His court-appointed lawyer ran with the insanity defence. However, Dixon was found guilty of murder.

When asked if he had any statement to make, he replied, 'All I have to say is I know nothing about the thing I am charged with.'

The judge sat the black cap upon his head. 'Thomas Dixon, you have been found guilty by the jury of the crime of wilful murder, and no one who has heard this case can doubt that you are responsible for the death of that unfortunate man, Alexander McLaren, and I am sorry to say, there can be no less doubt that you are responsible for the death of another person that same evening, and seriously wounding two others. I quite agree with the verdict which the jury has given, and I always think it right to say so, because the duty imposed upon them is a most serious and onerous one. I must say I think they would not have been doing their duty if they arrived at any other conclusion than the one they have come to.

It simply remains for me to pass upon you the sentence which the law imposes upon me, and it is that you be taken from hence to the place from whence you came, and from thence to the place of execution, and that you be there hanged by the neck till you shall be dead, and that your body shall afterwards be buried within the precincts of the prison in which you shall have been last confined, after your execution; and may the Lord have mercy on your soul.'

With the date of execution set for Monday 24 March, a mere twenty-two days after the court case, it was common for executions to take place three Sundays after the guilty verdict. While Dixon slept soundly in his prison bed and read copies of *Punch* magazine, a movement started to stir in Jarrow and Durham. A petition was signed by 2,153 people, which included ministers, medical men and magistrates, in a plea for leniency for Thomas Dixon. They cited his youth, his insanity and his grandfather's suicide as reasons for his death sentence to be reprieved. On 19 March, the governor of Durham Gaol received word from the Home Secretary, Sir Matthew White Ridley, that Dixon's death sentence would be stayed until further notice. Clemency was then granted and he was sentenced to life imprisonment. While his grateful and bedbound mother thanked the petition signers, Dixon showed indifference to the news his life had been spared.

Often favouring the words, 'I know nothing about it', Thomas Dixon had paid 5s for his murder weapon of choice. Today, 5s would be the equivalent of £15.75. Imagine walking along King Street tomorrow, popping into a shop and buying a gun for less than a £20 note. It is madness, isn't it? When he returned to Jarrow that fateful evening, Dixon had threatened to shoot his bedridden mother. Unstable, unwell and rightfully reprieved, this was the story of why Thomas Dixon would forever be known as the man who launched a bullet-ridden murder spree that ended outside Jarrow Cemetery on the dark night of 18 January 1896.

CHAPTER 9

MORRIS AND MARK REUBENS DO NOT WISH TO ATTEND

This is the story that features death in a city far from Jarrow. Like many families who moved to the Tyneside town, the Sproulls were Scottish. They arrived in Jarrow in the 1880s and lived on Beech Street by 1901. While William Sproull Snr worked as a ship rigger, his son William, aged thirty-four, joined the steamship *Dorset* as a second engineer. The ship crossed from Australia to Europe, but William's downfall would be Whitechapel, London. The ship arrived on the Thames on the morning of Monday 5 March 1909. By Monday night William would be dead.

William had gone ashore with Glaswegian Charles Malcolm. They left the ship at 8.30 in the evening and took the train to Fenchurch Street Station and had supper at the Three Nuns Hotel, Aldgate. They had two drinks each, one whisky and one beer. They left at 10 p.m. and made further calls to pubs from Liverpool Street to Houndsditch. At 10.45, they met two women, Emily Allen and Ellen Brooks, on Whitechapel High Street and after a lengthy conversation, they agreed to go home together. William had handed the women 30s in total by the time they stepped into the dimly lit house on Rupert Street. Twenty or so minutes later, Charles decided to return to the ship, but William wished to stay.

Once home to the Sproull family, Beech Street in the present day. (Source: Ewen Windham)

"No. 1,080. Pentonville Prison,
 "May 19, 1909.
 "My dear Friends,—I am writing these
last farewell lines to you all to tell you
that I feel quite resigned to my fate. I
hope God will forgive me for any harm
that I may have done to anybody, and I
trust my fate will be a lesson to my
friends. I feel happier now that I know
the worst, and thank God that my earthly
troubles will soon be all over. I am sorry
for the poor man that has gone, and I
hope he has gone to heaven. I hope his
relatives will forgive us for all the trouble
and pain we have caused them. Drink
has been the bottom of all this trouble.
So now good-bye, and God bless you all.
Thanking you all for your kindness and
sympathy to us in our time of trouble, I
remain your ever loving friend,
 "MARK REUBENS."

Mark Reubens' last letter from Pentonville prison, *Illustrated Police News*, Saturday 29 May 1909.

'What happened?' the coroner asked at the inquest into William's death.

'The door was opened, and two men came in. I was sitting on the edge of the bed,' Charles explained.

The coroner asked another question. 'Where was the deceased?'

'He was sitting in a chair and the fair woman was standing somewhere in the room, while the dark woman was lying on the bed asleep.'

'Had there been any signal given?' the coroner said.

'I did not notice any,' Charles replied.

'Should you recognise the men again?' the coroner questioned, and Charles shook his head.

The coroner had another question. 'Had the first man anything in his hand?'

Charles answered, 'Yes, a supple cane.'

Both William and Charles were attacked in the house. The bowling hat that had sat on Charles' head was split in two and he was struck across the face with the cane. His memories faltered and he told the coroner he could remember no more of his time inside the house.

'When you remembered anything, where were you?'

'I was leaning against a building in some side street. My head was aching, and I felt pain in my lip, which I found was bruised,' Charles said.

A fight had ensued in the house that had spilled out onto Rupert Street. After the commotion had died down and her lover Morris had returned to the house, Emily Allen had thrown the knife behind the gas stove. 'Oh Morrie, oh Mark, what have you done?' she asked, but later denied she had uttered those words. She knew William was lying in the road injured but instead of helping him she went to bed.

John Sharp, a nightwatchman, walked down Rupert Street at 1 a.m. on Tuesday morning. He spotted a man lying on his back against a kerb with

both his pockets turned out. 'Get up old man, you are lying in mud,' John said, approaching the person he assumed was drunk. He peered down at the body and when he noticed blood and a puncture wound on the chest, he searched for a police constable.

William was dead and had been stabbed with a blunt knife. The police tracked spots of bloods across the road to No. 3 Rupert Street. On the front door were fingerprints smeared with blood. Inside the house were brothers Mark and Morris Reubens with Ellen Brooks and Emily Allen. The motive had been robbery and the Reubens' anger towards William and Charles for sitting with the women.

The coroner read from a telegram sent by Brixton Gaol. 'Morris and Mark Reubens do not wish to attend.'

Another telegraph had arrived in Jarrow and was delivered by a police officer to William Sproull's parents. His father would have to travel to London to identify his son's body.

'I am so sorry the man is dead,' Emily Allen had said from prison. 'He was such a nice fellow. He would not hurt anyone and would have given us anything.'

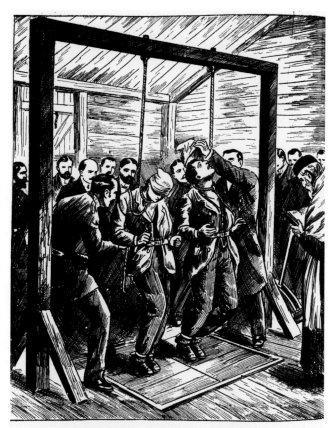

The Reuben brothers together in death, *Illustrated London News*, 1909. Note the abhorrent and offensive stereotype of hooked noses the Jewish men were given.

BROTHERS HANGED TOGETHER.

With the Reuben brothers later hauled to the inquest, they were asked about the bloodstained knife. 'The knife was broken, as it is now, when I last saw it,' Mark said.

'What do you know about the knife?' the coroner asked.

'Nothing,' Mark answered.

'We are in trouble enough without you making any more,' Morris had snapped at his brother.

Both Morris and Mark Reubens had broken down and cried at the inquest. Despite the coroner's belief that Mark had been responsible for the stabbing, the jury indicted both brothers for the murder of William Sproull. At the trial held at the Old Bailey on Friday 23 April 1909, Emily Allen and Ellen Brooks were acquitted. When sentenced to death, Morris had cried, 'Is there no recommendation for me?!'

While Mark had shrieked and attempted to escape the dock. 'Let me go!' he yelled, struggling with the police. 'God curse everyone in court!'

'Oh Mother, Mother dear, help me, set me free!' Morris sobbed.

Both men had to be dragged from court, their cries mixed with tears heard long after they had disappeared through the doors. Morris and Mark Reubens were dragged from court, their cries heard long after they disappeared through the doors. They were merchants who sold toys on street corners – their favourite was the teddy bear. At the ages of twenty-two and twenty-three, they would soon face the hangman's noose. They lived together, worked together and, ultimately, would die together.

'If I am to die on the gallows, I die as an innocent man. I did not stab Sproull, but I did take his watch and chain,' Morris told his friends days before the execution.

The Reuben brothers were hanged side by side at Pentonville Prison at 9 a.m. on Thursday 27 May 1909. The hangman, Albert Pierrepoint, with the assistance of his own brother, sent Morris and Mark to their graves. After William Sproull was buried, and Mrs Reubens mourned her two sons, Albert Pierrepoint would retire in 1956 with the deaths of more than 400 men and women on his fractured conscience.

CHAPTER 10

I HAVE DONE IT TO OLD CHARLIE

Three years after the end of the Edwardian era and seven months before the outbreak of the First World War, Jarrow would once again welcome alcohol, bloodshed, murder and death to Stanley Street. At No. 42 lived Charles Gribben. He was sixty-four-years-old, widowed, often danced when drunk, and was known as a kind, quiet and inoffensive man. Robert Upton, aged fifty, was his great friend. Upton, a father of five and widowed, had his youngest son, Joseph, residing with him. Robert and Joe lived on Albion Street and had hired Elizabeth Burden to clean their home. Burden knew Robert and Charles, and she worked for them both on a weekly basis. In fact, she stayed with Upton on the weekends and lived with Charles during the week. She had been separated from her husband for twenty-five years, and at the age of forty, she worked as a housekeeper. The inhabitants of Jarrow would later gossip about the unusual relationship between Burden and the two men, with the *Jarrow Express* suggesting it was sordid.

Robert Upton was calm when sober, but aggressive and abusive when drunk. He worked as a painter's labourer down at the Mercantile Dry Docks and he was taken with Elizabeth. On November 1913, Robert had requested Burden live fulltime with him. She refused and told him he was unsafe to be around when

The Mercantile Docks are shown to the far left of this glass slide of Jarrow. (Courtesy of Kevin Blair)

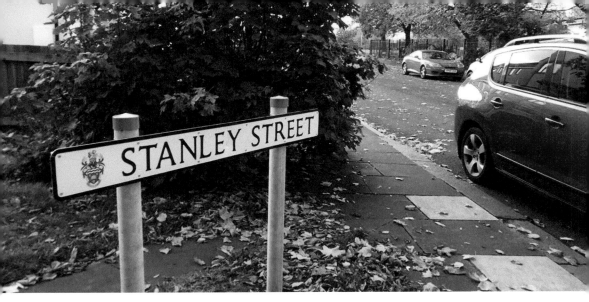

Stanley Street in autumn 2019. (Source: Natasha Windham)

drunk, then explained she had found work at John Bloy's house. Robert cried tears of distress when she left and said, 'I won't let you have either John Bloy or Charlie Gribben, for I'll do for the pair of you. I won't let you stay with Bloy. You will never get Charlie or Bloy. I'll swing for you first.'

Incredibly jealous, Glasgow-born Robert later moved into Gribben's home. In the downstairs of the terraced house at No. 42 Stanley Street there were two rooms. In the front room, Charles rested in the bed, while Robert and Joe slept on the floor. In the kitchen, lodgers James and Wilhelmina Evans slept soundly. There had been frequent quarrelling between Robert and Charles leading up to Christmas. On one occasion, Robert was escorted out of the house by James Evans after he had threatened Charles and kicked a hole through the door. The friction between the two friends revolved around Elizabeth Burden and Robert's jealously spiked frequently when drunk.

On Saturday 20 December, Gribben returned home from Elizabeth's father's home in East Jarrow. He was intoxicated, had danced the night away, and even though Elizabeth had asked her father to allow him to stay the night, he had still made his way to Stanley Street. When he entered the house, he said hello to Joe and sat on chair beside the fire. He was so drunk, eventually he tumbled to the floor and had fallen asleep on the mat in front of the roaring fire. A short time later, Robert arrived home. He was also inebriated and sent his fourteen-year-old son out at 11.30 at night for four pennyworth of pie meat. As Joe left, he watched his father lift the sleeping Gribben into bed.

After Joe had come home, Robert was in the kitchen with James and Wilhelmina. The older Upton had sat down, smoked, and then started to sing. A blunt Mrs Evans told him to go to his own bed. Robert fell asleep on the floor of the front room with his son beside him. At 3.30 a.m., Joe was awoken by a fight. He sat up and watched his father kneel on the bed against Charles' chest. 'Joe, he's cutting my throat!' Charles croaked, just as Robert smothered a hand across his mouth.

A panicked Joe climbed to his feet and rushed towards the bed. He shoved his father off Charles, but then spotted the razor in his father's hands. Charles tried to stand, but Robert ran at him again. 'You shall not get up,' he shouted and slashed at his victim's throat.

Blood had poured from the wound and Joe hurried to the kitchen and woke Mr and Mrs Evans with the shout of, 'My father has cut Charlie's throat!' he shouted, waking Mr and Mrs Evans.

When they returned to the front room, there was no sign of Robert Upton, and James Evans walked to the wounded and fading man.

'Jim, Jim,' the haemorrhaging Charles whispered.

James tied a cloth around Charles' throat. 'What's the matter?' he asked.

'Bob, Bob,' he replied weakly.

When James left the house in search of a policeman, Robert Upton returned in a frenzied state. The panicked Wilhelmina and Joe were sat in the kitchen. 'Where is Jim?' Robert questioned them.

'He has gone out,' Wilhelmina responded and watched him closely.

'I have done it now; I have done it to old Charlie,' Robert declared, the razor still in his hand. When he started to hack at his own throat, the frightened woman and boy fled through the back door.

Minutes later, Sergeant Dixon arrived at the scene. He blew his whistle for assistance, entered the house, and crept towards the front room. It was dark apart from the dying embers of the fire. As he reached the bed, he saw Charles Gribben on the floor. Gribben could no longer speak but used his eyes to signal to the corner of the room. Sergeant Dixon took the lantern from his belt and turned it on. The room was thrown into further light, and he was startled to find the bloodied Robert Upton dressed in a shirt and stood in the corner with a razor blade in his hands. Dixon attempted to secure the weapon but was unable to stop Robert. Once again, he slashed his own throat. This time, though, the wound was superficial.

'Is that you son?' Robert asked quietly. 'Give me a kiss, son. I have cut my own throat and will soon die. Charlie, you made me do it. You ruined me after me keeping you. Is he living? Is he dead? I hope he is.' Sergeant Dixon then cautioned Upton. 'I am sorry to trouble you, sergeant,' Upton replied. 'Have you got the razor I did it with? Is he alive? Gribben the traitor.'

Inspector Robson and Superintendent Yeandle were soon on the scene, and they arrested Upton and had the lifeless body of Charles Gribben taken by ambulance to Harton Workhouse Hospital.

'I have made a bad job of it, Inspector,' Robert admitted and when cautioned further he explained Charlie had insulted him. 'I want to tell you. I was full of drink, and I jumped up in a passion and got the razor and cut him. After that I don't know where I went, and I don't know where I cut myself. I had no clothes on, I know that, and I know it was the laddie who jumped up and shouted to the

man who sleeps in the other room.' He then asked, 'Where is the woman? Is she with Bloy? She was with me for two years come March and old Charlie came sneaking round and took her from me.'

Robert Upton declined to attend the inquest into Charles Gribben's death. Joseph almost fainted while giving evidence and at Dr Weir's request, he was sat in a magistrate's chair and handed a glass of water. When called as a witness, Elizabeth Burden was interviewed by Police Superintendent Yeandle.

'Have you been the cause of these frequent quarrels during the last month?' Yeandle questioned her.

'Yes,' Elizabeth confirmed.

'Is it more than three times?' he asked her.

'About three times in nineteen months,' she replied.

'How many times has Upton said he would swing for you?' he said.

'About three times. Each time I heard them quarrelling he threatened me,' she stated.

The foreman of the coroner's jury asked a question next. 'Was it on that account you went to Bloy?'

'Yes, I could not stand him; he was not safe to live with when in drink,' she said.

Superintendent Yeandle continued to talk to her. 'You led him to believe you married Bloy?'

'Yes, I could not live peaceably with him, and I wanted to get peaceably away from him. I think I did quite right,' she replied.

After the first inquest was adjourned and the second inquest was held, Robert Upton was remanded in custody for trial at the Durham Assizes for the murder of Charles Gribben. The trial started on Thursday 5 March 1914. Joe looked pale, afraid, and tearful when he gave his evidence. Wilhelmina Evans fainted when it was her turn to answer questions, and Robert's lawyer tried in vain to form a defence to reduce the charge to manslaughter. While citing Robert's father's suicide, a deteriorated mental state, drunkenness, and the fact Robert's aunt had been admitted to an asylum, none of the excuses would overturn the verdict and the jury retired for six minutes.

Asked if he had anything to say to the judge, Robert spoke of the night of the crime. 'My Lord, I did not know what I was doing; not one bit.'

Robert Upton was found guilty of murder and sentenced to death. On Tuesday 24 March 1914, four months before the First World War had begun, Robert was escorted to the scaffold in the grounds of Durham Gaol. In a private execution, he climbed the scaffold at 7.58 a.m. and was dead by 8 a.m. His inquest was held hours later where the coroner's jury viewed his body in a polished wooden coffin and his discoloured face was described as serene and at peace. Later that very day, he was buried in the grounds of Durham Gaol.

CHAPTER 11

NO MAN LIKES A WOMAN BETTER THAN I LIKE HER

We are nearing the conclusion of this book, so pause for a moment and imagine a marriage marred with rumours, suspicions, fines, and fists. Imagine physical fights with tongues lashing words of searing scorn with swearing, brawling, blood and a knife. Imagine the grief, anguish and heartbreak without a therapist in sight when you learned three of your sons were slaughtered in a war after their country deceived them to support and serve. Imagine you lived a chaotic, scarred and fearless existence when your partner attempted to murder you. Imagine you continue to raise anarchy and bedlam, forgive your partner, and have four convictions for common assault, ten for obscene language, a further four convictions for disorderly conduct, ten for drunk and disorderly behaviour, and one conviction for drunkenness. Imagine you are Mary Ann Bentham, the assailant from the Introduction, and the wife of Matthew Bentham. Imagine the town of Jarrow knows drama lives in your home, and that one day, when you visit your grandchildren, you will entertain them with a song while you encourage them to climb over the table. Just imagine your children

Matthew and Mary Ann Bentham accused of using the worst language Sergeant Herd had ever, well, heard. *Jarrow Express*, 26 August 1904.

OBSCENE LANGUAGE.

Mary Ann Bentham and Matthew Bentham (husband and wife) were charged with using obscene language in Monkton-road on the 20th inst.—Sergeant Herd said he was on duty in Grange-road when he heard the disturbance in Monkton-road. On proceeding thither he found that the defendants had the windows open and were using the worst language he ever heard in his life.—Inspector Padden corroborated. The male defendant came to the front, and witness told him that if he did not desist he would be locked up.—Mrs Bentham denied the charge, and said that she was not in the house from 11 p.m. until 8 a.m. next day.—This statement was corroborated by the husband and a neighbour who lives below them.—The latter stated that Mrs Bentham stayed all night with her.—As the evidence was of a conflicting nature in the case of the female defendant she was discharged, but the male defendant was fined 5s and costs.

Mary Foy was charged with a similar offence in Albion-street on the 20th inst.—Sergeant Herd said the defendant had her head out of the window whilst she used bad language.—Fined 2s 6d and costs.

BAD COMPANY. — At the Jarrow Police Court, yesterday, James Bentham, who has a long list of previous convictions against him, was summoned for having been drunk and disorderly in Ferry-street on the 22nd. This was the third time this month. He is due to go away with his regiment early next month, and the magistrates adjourned the case for a month in order to give him a chance of going away.

One of the Bentham's sons, James, in trouble. *Jarrow Express*, 28 August 1908.

died, you developed a desire for drink, your husband switched from your would-be murderer to your saviour, the First World War claimed the lives of three of your sons, you lived in a town where gossip was rife and despite your life story deserving a screenplay worthy of a dozen Bafta awards, you would have to settle for starring in the last chapter of a local history book instead. Just imagine, and then read these words. This is the story of Mary Ann Bentham's life.

Legendary quarrellers Matthew Henderson Bentham and Mary Ann Cain married in 1881. They were, by all accounts, entangled in a far from frictionless marriage. They brawled and battled, and were often arrested, fined, scolded, or lectured. They lived from Pearson Place to South Street, then Queen's Road, followed by Buddle Street. By 1912, their relationship had deteriorated further, and Mary Ann sought refuge at their daughter Eliza's home. Ship striker Matthew and his two convictions for obscene language, one conviction for assault, three convictions for drunk and disorderly behaviour and one conviction for obstructing a footpath were lonely without Mary Ann.

During a bank holiday weekend, on 3 August 1912, Matthew drunkenly strolled to Buddle Street and spotted his equally drunken wife walking towards their daughter's home. He crossed the road with a penknife in his hand and followed her. When she stopped and turned to look at him, he slashed at her arm and face. A curious crowd gathered around them, and Mary Ann collapsed on the path. Patrolling nearby and suspicious of the boisterous group, PC Marsh investigated the disturbance and entered a chaotic scene. He asked Mary Ann what had happened, and she blamed her husband.

Matthew waited close by, his bloodied hands clasped together. 'I did it and will go to the police station quietly; I don't want the handcuffs on,' he said when PC Marsh arrested him. On the walk to nearby High Street, Matthew continued to talk. 'I intended to murder her tonight, as I have had a terrible life with her, and now it is done.'

Police Inspector Hardy welcomed Matthew into custody, then went to No. 61 Buddle Street. He discovered a distressed Mary Ann in her daughter's bed. She had lost a worrying amount of blood and he sent for a doctor. Dr Weir examined his patient and discovered two deep lacerations on her right arm and left cheek. The cut to her arm had sliced into muscle and narrowly missed an artery. She was conveyed to Harton Workhouse infirmary for immediate treatment.

Further truths spilled from Matthew's lips as he settled in his police cell. 'I wonder what I stabbed her with?' he said while the penknife was discovered in his jacket pocket. He then admitted to a police officer that he had originally argued with his wife because she would not get him anything to eat. He blamed Mary Ann and complained whenever he was paid, she would take his money for drink.

Remanded in custody for a full week, Matthew objected, and claimed he had been treated poorly throughout his marriage. He then requested bail. Questioned whether he could afford the money, he explained his sons would pay. Police Superintendent Yeandle quashed the idea. Matthew then suggested his brother-in-law would provide the necessary funds because they agreed that he, Matthew Bentham, was the injured party in the marriage. Yeandle set bail at £10.

On 16 August, and with Mary Ann fit to provide evidence, Matthew was escorted to Jarrow Police Court, directly next door to the police station on High Street. When spoken to, Mary Ann informed the magistrates that despite her husband having attacked her, she did not wish for him to be punished. Matthew questioned his wife in court and accused her of asking for money while he had drunk at the Tynemouth Castle Inn. Mary Ann denied his version of events.

Matthew pleaded guilty to assault but refused the charge of wounding with intent because he said he could not recall the attack. He denied he told PC Marsh he had intended to murder Mary Ann, and said, 'No one but God and myself know the life I have had for years. I lost my temper, and I didn't know whether I was on my head or my feet. She has led me a queer life for years. I am very sorry

SOLDIER SMASHES A TRAMCAR WINDOW.

At Wallsend Police Court, on Tuesday morning, James Bentham, a private, was charged with damaging a tramcar window, the property of the Tyneside Tramway and Tramroads Company.

Sergt. Fernies said that on Saturday night he saw the man standing near the Ship Inn with a pint bottle of stout in his hand. Immediately after passing defendant he heard a crash of glass and found that Bentham had thrown the bottle at the tramcar. When asked why he had done it he said: "I did not get my money, and I am sure I am not going to fight without it."

Mr. J. C. Little, secretary of the Tramway Company, said the damage was valued at £1.

Defendant said he hoped the proceedings would not result in his discharge from the service.

The Clerk said he did not know what could be done with him. He had a bad record. Three times he had been a deserter, and he had also been convicted of larceny several times.

Bentham, who said he came from Jarrow, was fined 10/- and costs and ordered to pay the damage. He was also charged with being drunk and disorderly, and on this was handed over to the military authorities.

James Bentham in trouble again. *Jarrow Express*, 18 September 1914.

for what has happened. No man likes a woman better than I like her if she would do it right.' Despite granted bail once more, the magistrates deemed it a serious charge and sent the case to be trialled in Durham. Two months later, with his charge reduced to common assault, Matthew stood trial. He apologised for his actions and the jury convicted him. He was released immediately with no time to serve because he was simply bound over to keep the peace under twelve months' probation.

Despite her twenty convictions, Mary Ann lived a quiet yet sometimes volatile existence. By 1915, she remained married to Matthew because when a newspaper girl named Margaret Scott stood as a witness against her in court, Matthew sought revenge and attacked Margaret on Stead Street.

'Do you not feel shame for swearing such lies against my wife?' he had demanded to know.

'I'll give you three months more than your wife,' Margaret had replied.

 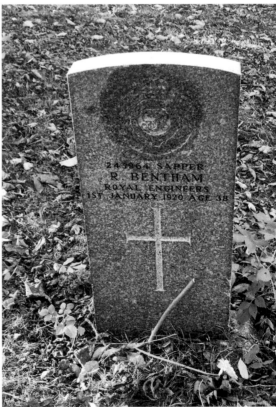

Above left: James Bentham's headstone in Jarrow Cemetery. (Photo taken by Stewart Hill)

Above right: Robert Bentham's headstone at Jarrow Cemetery. He was buried close to his brother, James. (Source: Natasha Windham)

With weapons that consisted of filthy language and his fist, he struck her with such force he perforated her ear drum. When she collapsed to the ground, he attempted to kick her but thankfully missed his terrified target.

Justice was swift against Matthew, and he was sentenced by the local Jarrow magistrates to a four-week custodial sentence with hard labour.

The Bentham children were never far from public scrutiny, especially Matthew and Mary Ann's troubled son James. He was born in 1883 and enlisted in the Durham Light Infantry in 1908. He subsequently served as a gunner in the First World War and tragically drowned near Hull on 16 April 1916. He was buried in Jarrow Cemetery. Thomas Bentham, a Palmers Shipyard labourer and father of two-year-old Annie, enlisted in the Durham Light Infantry and died of wounds on 22 August 1916 at the age of twenty-five. He was buried at Couin Cemetery in northern France. Robert was born in 1882. He enlisted in the Royal Engineers, and on the 19 January 1915, he survived an explosion where he was severely gassed. After spending three months recuperating in hospital, he was later discharged from the military in October 1916 due to sickness. On New Year's Day 1920, Robert, a father of four, succumbed to illness and was buried in Jarrow Cemetery. Younger brother Matthew had been born in 1896, and enlisted in the Durham Light Infantry. He miraculously survived the war despite being reported missing, then reenlisting before being discharged from service in 1919 because of deafness.

Imagine you waved goodbye to four of your sons as they left to fight in a war. Imagine two of them died within six months of each other, and you welcomed home two scarred and war-torn sons. Imagine another son died in 1920, your daughter died in 1937, your husband who you had battled for most of your lifetime died in 1940. Imagine 'Died' became your family motto before you succumbed to death at the age of eighty-one. Since 24 January 1945, you have rested in an unmarked grave at Jarrow Cemetery and are surrounded by further death, but when these words are read, and people learn of your story, they will remember you as the loving grandmother who, to the delight of her grandchildren, upturned the furniture, and encouraged them to clamber over the table and chairs as you sang an upbeat song about ascending the snow-capped, frozen and faraway Alps. Death might have plagued Mary Ann Bentham, but her story, both bold, depressing and eccentric, will live on in the pages of a local history book.

CONCLUSION

Jarrow was the town founded on the weary souls and broken spirits of the working class. It was the town where the affluent inhabitants sought sanctuary as councillors or magistrates and warmed themselves by their stoked fires on wintery nights while their poverty-stricken constituents were fined for stealing coal. It was the town where nets and snares would be cast at the cemetery, townsfolk willing to steal endangered birds from the skies while the Chairman of the hallowed grounds loitered by the gates waiting to confiscate flowers from the bereaved. It was the town where said chairman, Mr Ramsay, would lead those who mourned to his own bed of pristine plants while dictating only flowers bought from his land could be gifted to the graves of Jarrow's dead. It was the town where intoxicated residents favoured drink to reality while being lectured by purported gentlemen afraid of living without means. It was the town where the working class marched in 1936 – two hundred men, feet aching and armed with ten thousand signatures crossed three hundred miles by foot, arriving in London to grey faces of government officials who shrugged their shoulders at Jarrow's decline.

It was the town where Rachel Hazelwood and Fanny Weddell, in 1878, were charged with hurling obscenities at each other on High Street while Hazelwood attempted to fight a man twice her size. It was the town where James Stewart, in 1887, frequently exposed himself to married women on Caroline Street to Railway Street earning himself a two-month custodial sentence with hard labour. It was the town where PC McLean, in 1878, wandered upon a fearsome clash of shovels and frying pans as two Webbers with the first names Emma and Elizabeth, charged at Elizabeth Dixon along the back of Albion Street. It was the town where the same women with their domestic weapons in their hands and spiteful words on their lips, were chided by the constable for using foul language and fined 5s each while Dixon complained bitterly after the Webbers had smashed the back door of her home. It was the town where Elizabeth Walton, in 1881, spent so long bathing her clothes her impatient roommate

As an Orange procession was passing through Jarrow on-Tyne, on Saturday, a riot occurred. The mob threw stones at the processionists, and, but for the opportune arrival of the police, several lives would have been lost. Fighting occurred all the way to the Railway Station. The Orangemen proceeded to Sunderland.

Jarrow's Orange March riots were reported as far as Cornwall. *Cornwall Gazette*, 18 July 1879.

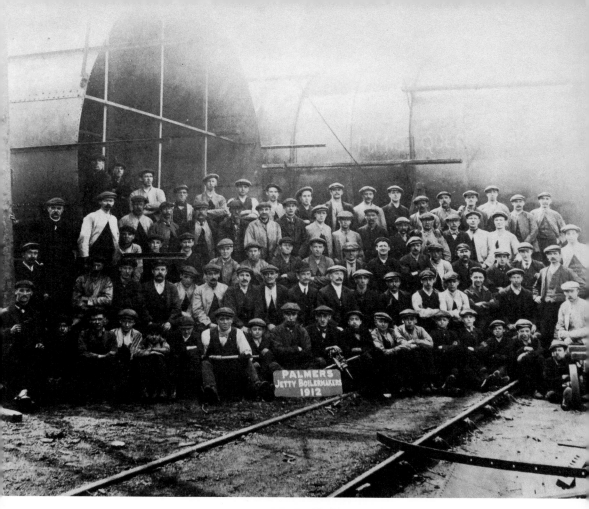

Above: Palmers Jetty Boilermakers, 1912. Photo taken by Elite Studios, Jarrow. (Source: Kevin Blair)

Right: A performance of *Babes in the Wood* by Harton Workhouse children at the Mechanics Hall. *Jarrow Express*, 4 March 1898.

GRAND ENTERTAINMENT AND CONCERT
By 60 Performers in Character.

OPERETTA,

BABES IN WOOD,

LAUGHABLE SKETCHES, &c.

FULL BRASS BAND,

MECHANICS' HALL, JARROW,

ON WEDNESDAY EVENING, MARCH 9th,

At 7·30. Doors open at 7 o'clock.

Front Seats 1s., Second Seats 6d., Children under 12
Half-Price.

By HARTON WORKHOUSE CHILDREN.

Councillor R. Archbold (Chairman Board of Guardians) Presiding, supported by W. Atkinson, Esq., of Hebburn, Vice-Chairman, and by The Mayor of Jarrow, Alderman W. H. Dickinson, Councillors John Armstrong and Z. Harris, D. Morrison and W. Connor, Esqs., Rev. Father Hayes, (Poor Law Guardians).

The relief of the Ladysmith during the Boer War, outside Palmers Shipyard gates, 1899. (Source: Kevin Blair)

SPIRITUAL LIGHT WANTED.

DEAR SIR,—Would you be so kind as to allow me to ask the Editor of your contemporary (the "Guardian") if he could throw any spiritual light upon the mummy found upon the island in mid-ocean by a Jarrow captain. He could perhaps throw some spiritual light upon the case of P.C. Maughan, who as a protector of the ratepayers' property, took the advantage to help himself. The Jarrow justices only gave him two months, instead of twelve at least. If some poor hungry unfortunate social wastrell had been caught by a P.C., he would have got years instead of months. There is a screw loose somewhere. Any spiritual light on the above will oblige, yours truly,

TABARCICUM.

PC Maughan complaint. He had been found guilty of robbery while drunk on duty, 28 April 1882.

Emma Turpin struck her with a fire poker and threatened to split her head open if she refused to vacate the wash house. It was the town where Mary Sanders, in 1900, was charged with using obscene language towards a Mrs Hill, and although admitting an exchange of compliments, she promised the magistrate, Councillor Johnson, that a Mr Fleming would vouch for her. It was also the town where Councillor Johnson fined Sanders 2s and 6d and had replied, 'If we were to have Mr Fleming giving testimony of all the women he knows, we would be here all day.'

It was the town where James Douglass, in 1901 and two days before Christmas, had chased his wife along Oak Street with a bottle in his hand as

A passion of indignation. *Jarrow Express*, 2 May 1884.

ASSAULTS.—John Scott was charged with having committed an assault on John Kirsopp, on the 26th of April. It appeared that both parties were contractors at the rolling mills, when a dispute arose between them, which terminated in Scott blacking complainant's eye. The offence was admitted, and the bench fined defendant £1 and costs.—Mary Jane Pearce was charged with assulting Elizabeth Burns, on the 22nd instant, at Queen's-road. The evidence disclosed the fact that an improper intimacy subsisted between defendant's husband and the complainant, and that the latter had been struck by defendant in a passion of indignation. She was fined 2s 6d and costs.

Jarrow was a football-focused town. This image shows the Jarrow Pioneers, 1907–1908. (Photo courtesy of Kevin Blair)

he used filthy expressions, hollered for all to hear, and earned himself a 5*s* fine after PC Miller had stumbled onto the scene at half eleven at night. It was the town where brothers-in-law Thomas McDonald and Cornelius Green fought on Commercial Road three days after Christmas in 1901. It was the town where PC Scott had wandered upon the fight and much to his shock had discovered Cornelius Green without a coat, shirt, or vest on, and the drunken McDonald without his coat on. It was the town where the fight had commenced after McDonald had accused his daughter of stealing, struck her, and thrown his children out of the house. It was the town where Green had attempted to protect his niece and in retaliation McDonald had struck him in the mouth, caused a bloodied battle in the street, and after McDonald's own daughter told the magistrates her father had caused the row, McDonald was fined 2*s* 6*d* and costs. It was the town where chimneysweep, Andrew Henderson, in 1907, had swung his brush at Mary Hall and called her foul names after they had argued about the extortionate price Henderson had charged Hall's neighbour. It was the town where the frustrated Agnes Walton, in the same month, had been accused of using abusive language towards her husband and his brother on Walter Street from midnight until 2am and was fined 2*s* and 6*d* for her runaway tongue.

Jarrow was the town where the vibrant characters torn from the pages of this book are now crumbling bones in aged coffins who left behind their rallying calls

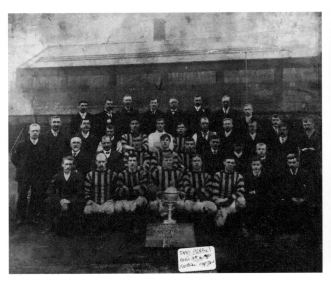 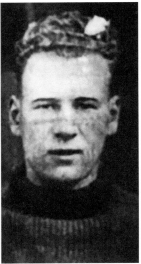

Above left: A talented local football team, the Jarrow Caledonians, who played at the football ground on Curlew Road. They won the Ingraham Cup in 1910. (Used with the permission of Margaret Davies)

Above right: Jarrow's own professional footballer James Horatio Thorpe. He played for Sunderland as a goalkeeper. Tragically, he received a deadly head injury during a match at Roker Park. Sunderland's opponent that day were a rough Chelsea side. *Sunderland Daily Echo*, 1936.

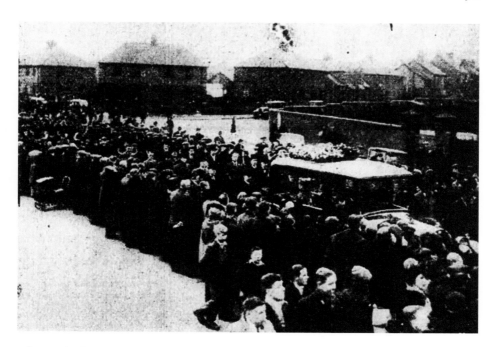

Above: The funeral outside Jarrow Cemetery. *Sunderland Echo*, February 1936.

Right: Thorpe's funeral notice, *Sunderland Echo*, February 1936.

THORPE.—Suddenly at Monkwearmouth and Southwick Hospital, on February 5, aged 22 years, James Horatio, dearly-beloved husband of May Thorpe (nee Lockhart) and beloved only son of James Horatio and Emily Thorpe. Interment Jarrow Cemetery, Monday; cortege leaving residence (11 York Avenue, Monkton, Jarrow) 2.30. All friends and neighbours kindly invited. Deeply mourned. S

in newspaper print. It was the town of scuffling women shrieking battle cries, with domestic weaponry and warring men, scuffed boots and drunken rages, broken windows and screams of murder in the night. It was the town of Police Superintendent Squire and Scott, Inspector Padden, Police Sergeants Hedley, Best and Merrells and Police Constable Blackett.

Today, Jarrow is a town where volunteers tend the neglected graves of the long-forgotten dead, and litter pickers meet on weekends to chase the rubbish away. It is the home of a thriving history group, and a supermarket where conscientious workers deliver food to vulnerable shoppers shielding from a pandemic. It is a town where amateur photographers share their delight of the River Don and its wildlife on a flourishing social media group, and it's a town where the inhabitants are proud of their heritage.

It was once the town where my grandad, a proud Jarrovian, was born in 1920. It was the town where he lived and thrived and wearily returned to after he had scaled pyramids in Egypt after the end of the Second World War.

TREASURED
MEMORIES OF
A LOVING HUSBAND FATHER AND SON
JAMES HORATIO THORPE
DIED 5th FEB 1936
AGED 22 YEARS
ALSO FATHER OF THE ABOVE
JAMES HORATIO ALFRED
THORPE
DIED 31st DEC 1956
AGED 74 YEARS
ALWAYS REMEMBERED
BY FAMILY AND FRIENDS

SPORTSMAN AND GENTLEMAN

Thorpe's headstone at Jarrow Cemetery.

UP AND DOWN THE RIVER.

MARCH.

Who, on this world of ours, her eyes
In March first open shall be wise,
If always on her hand there lies
A Bloodstone.

Blackett-street, which has hitherto been con-
sidered the pink of propriety, is just now bearing
—and deservedly so—a very bad name for drink-
ing among the female portion of the inhabitants.

o o o

Such a state of things as this is deplorable and
shows that there must be a serious amount of
neglect in household duties, as it is impossible for
them to do both things at once.

o o o

Above: Blackett Street, Jarrow, and neglection of household duties. *Jarrow Express*, 3 March 1899.

Right: A typical police court session in Jarrow, *Jarrow Express*, 21 October 1881.

Below: A strange find at Jarrow, *Jarrow Express*, 4 October 1889.

A Strange Find at East Jarrow.—On Monday, while some workmen were engaged cutting a drain in the brickfield at the St. Bede Chemical Works, East Jarrow, they found a human skull embedded in the clay close to the surface. The skull appeared to be that of an adult and broke into pieces when handled by the workmen.

Keeping a House of Ill-Fame.—Hannah Bella Ray and Margaret Curtis were charged with keeping a house of common bawdy, on the 4th inst. From the evidence it appeared that the two women, along with another not charged, jointly maintained a house in Commercial-road, where men frequently visited. Serts. Boiston and Best proved the charge, a man named Matthew Craggs, who keeps a shop near the house in question proved that defendants' conduct was the source of great annoyance. Defendant were ordered to find two sreties of £10 each, and to be bound in their own recognizance in the same amount, or go to gaol for three month.

A Barbarian.—Luke Richardson, a young man, was charged with exposing his person in the presence of Margaret Dinning, an elderly woman, of 3, North-street, on Saturday night. Complainant said defendant exposed his person, and made use of beastly expressions. Sergt. Hedley said he apprehended prisoner in Liddell's eating-house about half-past eleven o'clock. He was very violent, and tried to get away. Defendant, who had nothing to say, was committed to prison for one month, with hard labour.

He could not speak English.—John Joyce was charged with assaulting Patrick Hollerman on Saturday night. When complainant was called upon, not a word could be got out of him, his excuse being that he could not speak English. After a while the Bench ordered him to be locked up, and this loosened his tongue, and he spoke excellent English. He said he was on his way home when Ferry-street he met defendant and another man. The man held him while defendant struck him on the head with a bottle or glass. He was severely cut, bled very much, and had to get his head dressed by Dr Bradley. Fined 20s and costs.

Brawling in the Streets.—Michael Joyce, Patrick McDonnough, and Thomas Moran were charged, Joyce with being drunk and disorderly and assaulting P.C. Maughan; McDonnough with assaulting and resisting P.C. Maughan; and Moran with assaulting P.C. Maughan, on Saturday night.—P.C. Maughan said defendant was in North-street, creating a disturbance, and procuring the assistance of P.C's. Walton and Craggs, they took the defendants into custody. On the way to the Station the defendants were very violent, and kicked the officers.—P.C's. Craggs and Walton corroborated. It appeared that the crowd attacked the officers with stones. The defendants admitted that they were drunk, and expressed their sorrow at what had occurred. Fined 10s and costs each.

It was the town where he married my strong-minded grandmother in 1949 at St. Paul's Church, and it was the town where they raised their three children, but it was not the town where I held his hand for the last time in 2017. In the last three months of his life, he worried he had forgotten to put a blanket on his grandfather's pony at Red House Farm and shared his anxieties that he might miss a 1950s appointment to view a house on York Avenue. I settled at his bedside one afternoon, on a scorching summer's day, and I held his hand, and read countless articles from the *Jarrow Express*. He suffered from late-stage Alzheimer's, but for a fleeting moment, as I recited stories from the past, his eyes were emotive and alive.

We have reached the end of the book and weaved our way through the Jarrow of the past at a winding pace, and suddenly I realise social history captured in newspaper print is not forever stagnant and lifeless, it is as rich and vibrant as my grandad's hazel eyes were that day in the summer of 2017.

DANCING IN THE MOONLIGHT.

Those who mistakebly understand that peaceableness reigns on the suburbs of our borough at the witching hour of night—those who entertain the idea that dancing classes are held only within four square walls—and those who think that the scenes witnessed on Bede Burn-road are compatible in the strictest sense with the law so far as it concerns a spoilation of the public peace, evidently are unacquainted with the dancing class catalogued to hold its meetings on the aforesaid road at the unearthly hour mentioned. On this thoroughfare at the commencement of this week many persons were gathered together, the indispensible musician—indispensible under the circumstances—being one of the company serenading. The musician acquired suitable sitting accommodation on some of the railings bordering the roadway, and whilst he energetically dispersed dance music the company engaged in a trip on the fantastic toe. The proceedings were successful—no police constable was present, and the midnight festival expenses were mitigated by the use of a galaxy of heaven's adornments as gaslights and also by the utilization of the new road for a waxed floor. It would not be difficult to decide whether the holding of a dancing class on this important thoroughfare at midnight is a nuisance; and it would be still less difficult to decide regarding its being a source of annoyance.

Above: Drone shot of graves at the cemetery, summer 2020. (Courtesy of Ian Turnball)

Left: Dancing in the moonlight on Bede Burn Road, 25 August 1885.

Above left: Kevin Blair's postcard of Bede Burn Road, 7 March 1906.

Above right: An unknown Victorian Jarrow couple ready with a rifle. (Photo courtesy of Kevin Blair)

SALVATION NUISANCE.

DEAR SIR--There are a number of people living in the vicinity of Commercial-Road complaining, and well they may, of the disturbance caused by the Salvation Army Band parading the streets at 6 o'clock on Sunday morning last. Such discordant sounds as those given gratis by the Salvation Army Band so early in the morning should be put a stop to. I need not tell them of the very large number of families who don't get to bed before Sunday morning and who need rest and quietness. I was told by a friend of mine that if all the " prayers" showered upon them last Sunday morning, in this locality, were answered it would be anything but pleasant for them. ' Go ye into the highways and hedges and bring them in,' but nothing is said about rousing people out of their sleep at such a hour. I am sure there was more sin caused by the noise of the band than good done by them. Why cannot the Salvation Army people conduct their anniversary services without disturbing people who love to go to the house of God, but not at the sound of a brass band. I really think our Council should take this matter up and see if they cannot stop their towns people from being so disturbed.--I am, Sir, Yours obediently, LET 'US SLEEP.

Above: Let us sleep – the brass band nuisance, 14 September 1883.

Right: My grandad, Jim Windham, on Alnmouth Beach, Northumberland, in 2001. His ashes were scattered on the same stretch of sand in 2017.

ABOUT THE AUTHOR

With a keen interest of crime in the Victorian period, Natasha Windham has spent many years focusing on the history of Jarrow because of her familial ties to the town. Her paternal grandfather, Jim Windham, was born in Jarrow in 1920 and began his career at the age of fourteen delivering telegrams to ships along the River Tyne. He retired from his position as the postal inspector of Jarrow aged sixty, and once wrote, 'We celebrate a family's unity, achievements, good fortune, and for our youngest members of the clan their promise, dreams and hopes. Life is a very winding trail indeed but in spirit we will be with them every step of the way.' Since his death in 2017, Natasha has delved further into Jarrow's past and has discovered countless tales of tragedy that often evoke the words of her grandfather. Life was indeed a winding trail for many, and she believes their stories need to be told.